NOTE ABOUT THIS SERIES

TO GET HOLD OF THE INVISIBLE, ONE MUST PENETRATE AS DEEPLY AS POSSIBLE INTO THE VISIBLE. THIS IS THE ESSENCE OF PAINTING. § THE ARTIST MUST FIND SOMETHING TO PAINT. PAVEL TCHELITCHEW SAID, "PROBLEMS OF SUBJECT-MATTER HAVE BEEN LIKE OBSESSIONS — IMAGES HAVE HAUNTED ME SOMETIMES FOR YEARS BEFORE I WAS AT LAST ABLE TO UNDERSTAND WHAT THEY REALLY MEANT TO ME OR COULD BE MADE TO MEAN TO OTHERS." THESE ESSENTIAL IMAGES AND THEMES IN A BODY OF WORK — PEOPLE, PLACES, THINGS — ARE EQUIVALENTS OF THE ARTIST'S INNER, INVISIBLE REALITY. § THE ARTBOOKS IN THIS SERIES EXPLORE SPECIFIC SUBJECTS THAT HAVE MOVED CERTAIN ARTISTS AND STIRRED OUR DEEPEST RESPONSES.

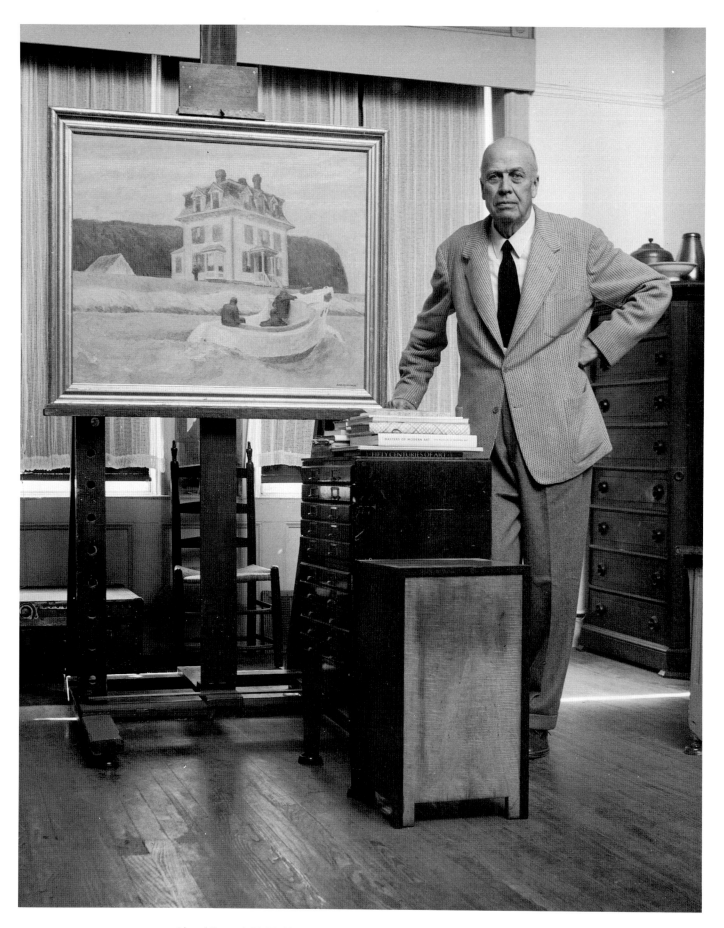

Edward Hopper in his Washington Square studio, 1955, photograph by Sidney Waintrob

A CHAMELEON BOOK

EDWARD HOPPER'S NEW ENGLAND

Carl Little

POMEGRANATE ARTBOOKS, SAN FRANCISCO, CALIFORNIA

A CHAMELEON BOOK

Complete © 1993 Chameleon Books, Inc.
Text © 1993 Carl Little

Published by Pomegranate Artbooks
Box 6099, Rohnert Park, California 94927

Produced by Chameleon Books, Inc.
211 West 20th Street, New York, NY 10011

Creative director: Arnold Skolnick
Editorial assistant: Lynn Schumann
Managing editor: Carl Sesar
Composition: Larry Lorber, Ultracomp
Printer: Oceanic Graphic Printing, Hong Kong

Library of Congress Cataloging-in-Publication Data

Little, Carl.
 Edward Hopper's New England / by Carl Little.
 p. cm.
 "A Chameleon book."
 ISBN 1-56640-315-4
 1. Hopper, Edward, 1882-1967 — Criticism and
interpretation.
 2. New England in art. I. Hopper, Edward, 1882-1967.
II. Title. ND237.H75L58 1993
759.13 — dc20 93-17447
 CIP

FOR CYNTHIA

ACKNOWLEDGMENTS

Anyone writing on Edward Hopper has the great fortune to have the work of a number of dedicated scholars on which to draw. Hopper has been lucky with his champions; from Guy Pène du Bois and Lloyd Goodrich to Brian O'Doherty and Gail Levin, his life and art have fallen into expert hands.

Several Mount Desert Island libraries were most helpful in obtaining Hopper material for me. I extend special thanks to the staffs of the Northeast Harbor Library, the Thorndike Library at College of the Atlantic and the Jesup Library in Bar Harbor.

Grateful acknowledgment is also due my brother David Little, my mother, Juliana Little, and comrade-in-art Arnold Skolnick for their helpful feedback and for coming up with several key documents. Of course, this book couldn't have happened without Peggy, Emily and James.

This book is especially dedicated to the memory of Lucien Goldschmidt (1912-1992), mentor and friend.

Carl Little

We would like to express our gratitude to the museums, galleries, and their staffs for providing us with many of these images. Special thanks are due to Anita Duquette of Whitney Museum of American Art, Betty Krulik of Spanierman Gallery, Eric P. Widing of Richard York Gallery, and the staff at Art Resource.

Arnold Skolnick

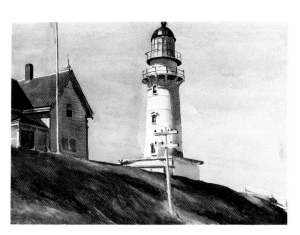

[LIGHT AT TWO LIGHTS], 1927
Watercolor on paper, 13¹⁵⁄₁₆ x 20 inches
Collection of Whitney Museum of American Art, New York
Josephine N. Hopper Bequest 70.1094

EDWARD HOPPER'S NEW ENGLAND is an exploration of landscape and a legacy of light. Encompassing the Maine coast, Cape Ann, Vermont and Cape Cod, Hopper's New England comprises a quiet Ogunquit cove, a bold headland on Monhegan Island, Gloucester's sail-filled harbor and sunlit streets, the graceful bends of the White River, and South Truro's hills and dunes.

Hopper's New England is also a study in architecture: Victorian mansions and shady hotels, a sugar house and a box factory, churches and filling stations, Two Lights on Cape Elizabeth and the custom house in Portland, summer cottages at Wellfleet and the tenements of Gloucester's Italian quarter.

Beginning in 1912, Hopper (1882–1967) spent nearly every summer of his long life in New England. These seasonal visits, which often stretched on well into autumn, proved highly productive times. Consider, for instance, the many superb watercolors he painted during his stays on Cape Ann in the 1920s or the inventory of masterful oils he produced on Cape Cod in the early 1930s. Even on relatively brief sojourns to Vermont the artist turned out a body of memorable watercolors that remain as fresh in feeling as the day they were painted.

New England provided Hopper with motifs which he would turn into icons of American art. Perhaps the best known of these is the lighthouse. Artists had been drawn to this subject since the first one was built on the New England coast in the early 1700s, but it was Hopper who made of the lighthouse a representative and enduring American image. His paintings of these coastal sentinels, standing out against the glorious blue of a Maine or Massachusetts sky, remind us of the truth of Emerson's observation, in the opening line of his second essay on nature: "There are days which occur in this climate, at almost any season of the year, wherein the world reaches its perfection."

Yet when Hopper headed north-northeast each summer, he didn't simply leave behind his dark vision of America, as expressed in those often desolate city scenes—the grim eateries, dreary theaters and soulless offices—which have received the lion's share of critical attention. Look at his *Cape Cod Evening,* 1939, *High Noon,* 1949, or **32, 34** *A Woman in the Sun,* 1961: in these paintings, and in other New England pieces, p. 16 Hopper's figures appear just as alienated as those in his New York City pictures. As Henry David Thoreau well knew, a metropolis is not requisite to our leading "lives of quiet desperation."

All the same, New England afforded Hopper the great yearly escape from the city. He was clearly an individual who required—and thrived on—peace and quiet. While the routine he established of winters in New York and summers in New England was a common one among artists of his day, perhaps no other painter stuck to it as religiously as he did.

New England led Hopper into realms of light and shadow. Under the spell of the region's translucent and tonic air, he painted away to his heart's desire. His very soul, it would seem, fell in sync with the poetry and spirit of the place. If indelibly American in his art, Hopper was also thoroughly New England.

Early Development: New York and Paris

Edward Hopper was not a New Englander by birth. To use the parlance of native Mainers, he was "from away"—but not from that far away. He was born and raised in Nyack, New York, located on the Hudson River due north of the Jersey Palisades.

Hopper grew up sailing; and he studied the ships that dropped anchor in the port and the yachts built in the Nyack shipyard. His love of boats and the water would lead **5** him to paint a variety of nautical subjects along the New England coast, from trawlers docked in Rockland, Maine, to yawls sailing the sunlit reaches of Cape Cod Bay.

Art studies began in 1899, when, at age 17, Hopper enrolled in the Correspondence School of Illustrating in New York City. A year later, he switched to the New York School of Art, initially continuing his studies as an illustrator, but soon dropping these classes in favor of painting. His teachers there were William Merritt Chase, Robert Henri and Kenneth Hayes Miller; and his fellow students made up what would turn out to be an illustrious lot. Artists Rockwell Kent, George Bellows, Patrick Henry Bruce, Gifford Beal, and Guy Pène du Bois, poet-to-be Vachel Lindsay and future actor Clifton Webb numbered among his easelmates.

In his autobiography, *It's Me O Lord,* Kent provides a first-hand account of classes at what was commonly known as the Chase School. He differentiated the teaching philosophies of its distinguished trio of professors: "Chase…taught us just to use our eyes,…Henri to enlist our hearts,…Miller…to use our heads."

Of the three teachers, Henri had the strongest influence on the young Hopper. He taught his students to enlist not only their hearts, but also their paint brushes. "When the brush stroke is visible on the canvas," he explained, "it has a size, covers a certain area, has its own texture…It has its speed and direction."

Hopper's oils from the five-plus years he spent at the school testify to Henri's good counsel. The brush strokes, forcefully deployed, are tangible on the surface of the canvas. The idea of paint as paint would remain a basic principle for Hopper throughout his career. His Monhegan Island oil sketches from the summers of 1916–1919 are particularly muscular in their paint-handling.

Later in his life, Hopper would claim that it took him ten years to get over his teacher, and yet he would also praise Henri to the heavens. In an article he wrote on John Sloan in *The Arts* in 1927, Hopper said of Henri, "No single figure in recent American art has been so instrumental in setting free the hidden forces that can make of an art of this country a living expression of its character and people." Echoing this sentiment, Sloan himself called Henri "the emancipator."

In 1906, Hopper did his first stint as a commercial illustrator, a profession he grew to abhor, although it kept food on the table and served to further train his eye and hand. While he sometimes managed to work with subject matter to his liking—performers, railroads, sailing scenes—the format of the magazines and books he illustrated forced him to turn out limited, appeal-to-the-public artwork.

One might venture to say that the strictures of commercial illustration led Hopper to push the esthetic envelope in his later work. In a manner of speaking, he wreaked revenge upon the generic magazine art that was his stock and trade for nearly 20 years (he gave it up in 1924, after an exhibition of his watercolors sold out). Images of posh resorts were traded for those of lone New England houses; and fashionable figures were transformed into men and women clad in existential despair.

Also in 1906 Hopper made the first of three trips to Europe. He was especially drawn to Paris; certain qualities of the city appealed to him, including its "luminosity," which would become a major element in his New England paintings. He also made special note of the many double-pitched mansard roofs, a motif he would return to

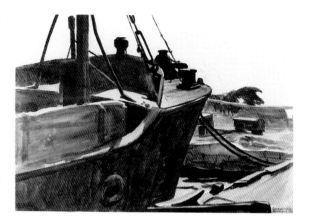

BEAM TRAWLER TEAL, 1926
Watercolor, 13½ x 19½ inches
Munson-Williams-Proctor Institute, Museum of Art
Utica, New York

when he worked in Gloucester in the 1920s.

Perhaps recalling his boyhood alongside the Hudson, Hopper frequented the banks of the Seine and did many paintings of its riverboats and bridges. Among his Paris work are oil sketches of Notre Dame on the Île de la Cité. Hopper would travel a great distance, both literally and artistically, from these brusque studies of the famous French cathedral to his light-filled watercolor of the Methodist Church in Provincetown painted nearly 25 years later.

The Shaping of the Artist: "Deaf to all faddish chatter"

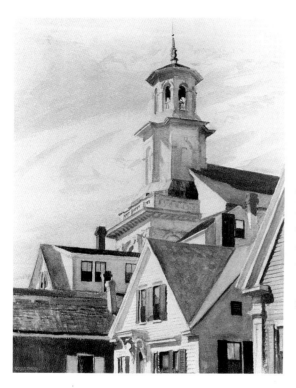

METHODIST CHURCH, PROVINCETOWN, 1930
Watercolor, 25 x 19¾ inches
Wadsworth Atheneum, Hartford, Connecticut
The Ella Gallup Sumner and Mary Catlin Sumner Collection

Comparing Paris with New York, on several occasions Hopper referred to the latter as being "raw." It was this rawness that was grist for the art of the Ashcan School, a group of artists known for painting the less picturesque aspects of the city—"the grime and raw industrial bulk of the metropolis," as one critic has put it. Led by Henri, these artists were considered by many to be revolutionaries, although Chase once mockingly referred to them as "the Depressionists."

While Hopper bridled at sometimes being linked to this school of painters, he nonetheless was influenced by them. He even showed with members of the group on several occasions, including the famous "Exhibition of Independent Artists" in 1910. Their appreciation of subject matter that fell outside the academic tradition and might be considered unbecoming of the attention of a fine artist surely came to Hopper's mind when he turned to painting tourist hotels and nondescript neighborhoods, filling stations and empty rooms.

If a bit disingenuous in his denial of an Ashcan School kinship, Hopper was otherwise quite open in his passion for certain artists of the past, among them Rembrandt, Goya, Daumier, Degas, Manet and Courbet. One of the few Americans on his favorites list was Thomas Eakins, the Philadelphia artist renowned for his realist canvases. Hopper once told an interviewer that Eakins was, in his opinion, "greater than Manet."

Reading the following passage from a letter Eakins wrote to his father, one cannot help but think of Hopper and his art, in particular the New England work:

The big artist...keeps a sharp eye on Nature and steals her tools. He learns what she does with light, the big tool, and then color, then form, and appropriates them to his own use. Then he's got a canoe of his own, smaller than Nature's, but big enough for every purpose.

Hopper handled the "big tool" with authority throughout his career, capturing in such paintings as *Lighthouse Hill,* 1927, and *Cape Cod Morning,* 1950, the intensity **11, 30** and purity of northern light. He once said in an interview that in his years as an illustrator all he wanted to do was "to paint sunlight on the side of a house." In this regard he was not unlike N. C. Wyeth and other artist-illustrators of the day, who found themselves tied to the drafting table, dreaming of the unfettered spaces of the New England coastline.

Considering the great influx of modern European art to New York in the 1910s, and in light of Hopper's direct exposure to so many contemporary styles, it's something of a miracle he didn't succumb to any of the isms of his day. Yet, as Guy Pène du Bois puts it in his 1931 monograph on the artist, Hopper "is so deaf to all faddish chatter that he can, without strain, with no stunting exercise of will, remain himself."

The international Armory Show in 1913, in which Hopper took part (and where

he sold his first oil, a marine called *Sailing*), knocked many American painters silly. Hopper would have probably concurred with his fellow painter Randall Davey as to the mixed merits of this landmark exhibition,which introduced many European artists to an American audience: "It [the Armory Show] certainly influenced many young artists toward abstraction, and as good as some of it is I feel that a large percentage followed in its path more through being on the bandwagon than through conviction."

Hopper avoided bandwagons like the plague. Although he was close to a number of painters, including du Bois and Clarence Kerr Chatterton, he tended to keep to himself. The fullest description Leon Kroll gives of his friend in his *Spoken Memoir* (1983) bespeaks a detached individual: "Hopper was never conversational, nor was he exactly in the group as much as the rest of us were." In an interview, Hopper's wife, Josephine Verstille Nivison, provided further testimony along this line: "Sometimes talking with Eddie is just like dropping a stone in a well, except that it doesn't thump when it hits bottom."

Kroll painted with Hopper during the latter's first summer spent in New England, in 1912, in Gloucester on Cape Ann. This picturesque port, once headquarters of the Atlantic fishery, was well known to artists. The likes of Fitz Hugh Lane, Winslow Homer, Maurice Prendergast, John Sloan, and Childe Hassam painted there, focusing their attention on harbor and coastal views, relishing the region's light and sparkle.

Some of Hopper's oils from this initial visit to the coast have a distinct French feel
1 to them. In its light and composition, *Gloucester Harbor* recalls any number of Impressionist views of Brittany. What is distinctly Hopper in this picture is the house in the foreground, its chimneys casting precise shadows, its shutters and white trim carefully rendered.

2 Even more in line with later work is *Italian Quarter, Gloucester*. In this canvas, Hopper already displays his fascination with architectural configurations, how one roofline plays off against another, how windows lend a structure personality, how a house sits in its surroundings. One thinks of a bit of counsel Henri gave his students at the Chase School:

> I want to see these houses solid, I want them to feel like houses. I don't care about your drawing and your values—they are your affair. They will be good if you make me sense the houses and they will be bad, however "good" they are, if you do not make those houses live.

Also falling into what would become the Hopper canon is *Squam Light,* painted in Annisquam, a small harbor town near Gloucester. *Squam Light* was the first of many watercolors and oils that the artist would paint of lighthouses over the years. While not as dramatic as later renderings, the picture establishes the uphill perspective Hopper would favor; and his penchant for capturing sunlight on white structures begins to manifest itself.

On his next visit to New England, Hopper went further north, to Ogunquit, on the southern Maine coast, where he would spend the summers of 1914–1915. Like Gloucester, Ogunquit was well known to painters. The authors of *A Century of Color: Ogunquit, Maine's Art Colony, 1886–1986* provide a list of over 300 artists who have spent time at this scenic spot at one time or another, drawn to its coves, beaches and pristine waters. In Hopper's day, inexpensive summer rentals and several art schools also

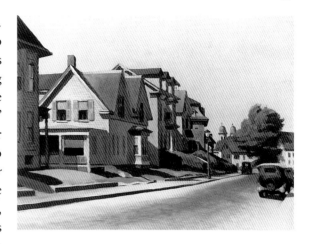

STREET SCENE, GLOUCESTER, 1934
Oil on canvas, 28 x 36 inches
Cincinnati Art Museum
The Edwin and Virginia Irwin Memorial 1959.49

Early New England Visits: Gloucester, Ogunquit, Monhegan

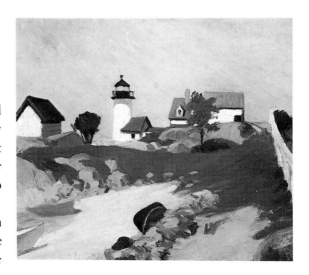

SQUAM LIGHT, 1912
Oil on canvas
24 x 29 inches
Private collection

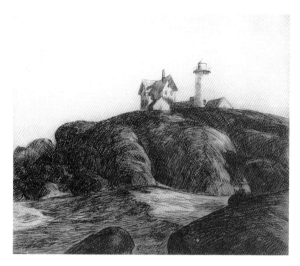

THE LIGHTHOUSE (MAINE COAST), 1923
Etching, 11½ x 13⅞ inches
Collection of Whitney Museum of American Art, New York
Josephine N. Hopper Bequest 70.1031

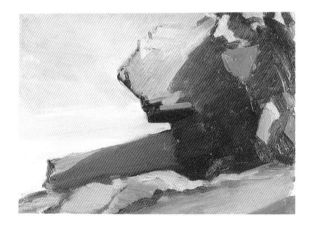

[ROCKY PROJECTION AT THE SEA], 1916-1919
Oil on composition board, 9 x 12⅞ inches
Collection of Whitney Museum of American Art, New York
Josephine N. Hopper Bequest 70.1310

Hopper, Etcher and
Watercolorist

helped attract painters.

Knowing of Hopper's early love of boats, it's not surprising he chose to paint a picture of dories, those narrow flat-bottomed fishing craft with high sides and sharp prows that one finds anchored in Maine coves. In *The Dories, Ogunquit,* a 1914 oil, **9** several of these small boats are framed by shadowy coastal outcroppings, their sunlit hulls bright against a profoundly blue sea. A later treatment of this subject, *The Dory,* **8** 1929, stands among Hopper's most beautiful watercolors.

Going from the relatively serene landscape of Ogunquit to the towering headlands and crashing surf of Monhegan Island further up the Maine coast provides a lesson in contrasts. Lying ten miles from Port Clyde and twenty from Boothbay Harbor, Monhegan might appear a rather forbidding place to set up one's easel, yet by the 1920s many a painter had made the voyage out. As William Cullen Bryant once observed, "Art sighs to carry its conquests into new realms."

Henri took his first trip to Monhegan in 1903, the advance scout for a remarkable group of artists, among them his prize students, Kent, Bellows and Hopper. They would hungrily paint up this remote island world, entranced, after the sooty existence of the city, by the clear air, precipitous granite cliffs, and rocky shores holding forth against an often awe-inspiring sea.

"To paint the sea directly on Monhegan requires a high degree of pure physical vigor," writes George R. Havens in his biography of Frederick J. Waugh, an artist who worked on the island a few years before Hopper did. "He has to go on foot, laden down with easel, paintbox, canvases, an extra coat perhaps for additional warmth, and certainly a sustaining lunch for a long day's work outdoors."

We don't know what all Hopper carried along on his painting excursions on Monhegan. We do know that he worked on location and that he favored wood panels rarely bigger than 12 x 16 inches, the perfect size for easy carrying over the sometimes treacherous island terrain.

On the evidence of the oil sketches he made on Monhegan in the summers of 1916–1919, Hopper was quite smitten with the place. Among his favorite motifs was Blackhead, one of the island's prominent headlands. He painted it from several different distances and in various weathers, so that its demeanor—"its dark face," as Kent described it—changes from study to study. He also explored the many indentations of the island shoreline, training his eye on shadow configurations, on granite outcroppings set against the blue or gray of sky or sea.

The imposing island landscape required a forthright approach; as never before, or after, Hopper laid the paint on thick, modeling the strata of rock, sea and sky in loose, powerful strokes, often working the paint up into rich impastos. Even a painting of the Monhegan Island Light, a beautiful stone tower built in 1824, and its surrounding buildings, has the pleasing quality of a sketch—the sketch nonetheless of a sure hand and of an eye already greatly enamored of New England architecture.

In 1915, Hopper took up etching, a medium he worked in off and on until 1923 (his last prints, drypoints, were made in 1928). Etching was not simply a sideline: the more than 60 prints Hopper made represent a significant contribution to the history of American printmaking. He brought the same care and focus to these works as he did to his oils and watercolors—"As if the etcher's job," he wrote in 1925, "was to do

otherwise than to draw honestly on the plate his vision of life."

While many of his etchings deal with city subjects—his printing press remained in his Washington Square studio all his life—the few New England pieces are among his finest. *The Monhegan Boat,* 1919, captures the open-air experience of passengers headed out to the island. The etched lines are loose yet precise, the composition made dynamic by the prow of a lifeboat on the ferry's deck and by the sails of a ghostly sailboat passing in the background. For anyone who has made the trip to Monhegan in recent years, on the *Laura B.* out of Port Clyde, the scene has changed little since Hopper's day.

Another New England subject, *The Henry Ford,* dates from Hopper's second visit to Gloucester, in 1923, the summer of the city's 300th anniversary celebration. In the print, spectators are shown standing and waving on a rocky point as the magnificent schooner sails past. Hopper probably based his image on the nautical parade the ship took part in that August.

Hopper's stay in Gloucester in 1923 also occasioned his full-fledged leap into watercolor painting, a medium he had made use of infrequently up to that point. Working alongside his friend and fellow Henri student, Jo Nivison, who would become his wife the next year, Hopper produced a number of views of Gloucester landscape and architecture as well as studies of trawlers docked in the harbor.

Like Homer, John Marin, William Zorach, Andrew Wyeth and other artists before and after him, Hopper came to realize how ideally suited watercolor was to handling New England light. According to Lloyd Goodrich, Hopper's watercolors were "practically all painted on the spot, and often finished in one sitting," which helps explain their remarkable freshness. Goodrich described Hopper's watercolor method as follows:

> They [the watercolors] began with a pencil drawing, precise though not detailed; but from then on they were built with the brush. The medium was kept transparent, without gouache or Chinese white—hence their luminosity.

The medium garnered Hopper the fame he had missed out on for years: the **16** Brooklyn Museum bought *The Mansard Roof,* 1923, the winter after it was painted, and his one-person show of watercolors at the Frank K. M. Rehn Gallery in New York City the fall of the following year was a sellout. In his early forties, Hopper was coming into his own.

A collection of Hopper's portraits of Gloucester houses might serve as a guide to the architecture of that seacoast city. In the course of four visits to the area, in 1923, '24, '26 and '28, he painted a variety of structures. As was his habit throughout his career, Hopper often provided the names of the owners of specific houses in the titles of his paintings, thereby lending further personality to these domiciles.

The detail in Hopper's watercolors can be quite precise. In *Haskell's House,* 1924, for example, you can make out the decorative ironwork on the roof of this stately example of Second Empire architecture. Likewise, the spire of Gloucester's Universalist Church, subject of a 1926 watercolor, is rendered in a manner that allows us to read its various structural features. The composition of the picture, that of a steeple rising out of the rooftops of surrounding houses, would be repeated in the equally p. 8 beautiful watercolor *Methodist Church, Provincetown* from 1930.

THE MONHEGAN BOAT, 1919
Etching, 13¼ x 15¹/₁₆ inches
Collection of Whitney Museum of American Art, New York
Josephine N. Hopper Bequest 70.1042

THE HENRY FORD, 1923
Etching, 12 x 15 inches
Photograph © 1993 The Art Institute of Chicago
All Rights Reserved
Gift of The Print and Drawing Club, 1944.161

Hopper's Gloucester

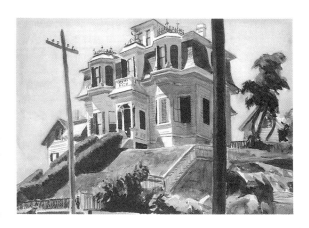

HASKELL'S HOUSE, 1924, Watercolor on paper, 14 x 20 inches, Private collection

The many studies of Gloucester buildings illustrate a key architectural principle: light has the power to give an inert, man-made construction the living quality of nature. In Hopper's hands, the elements of a facade—dormers and gables, awnings and windows—become receptacles of light and shadow that change in character, even in form, as the sun moves up or down the sky.

Hopper didn't just paint handsome or remarkable buildings in Gloucester; his vision was a democratic one. He did studies of shacks and tenements in the city's Portuguese and Italian quarters, and he was not adverse to industrial subjects, as witness *Box Factory, Gloucester,* a 1928 watercolor. He was also drawn to the **4** railyards, where he painted the 1928 oil, *Freight Cars, Gloucester.* **3**

The Bootleggers, 1925, which depicts rumrunners in a launch approaching a **17** stately mansard-roofed house, has to number among Hopper's most unusual oils. In its suggestion of a narrative, the piece calls to mind the artist's book illustrations. No doubt the painting grew out of the rash of bootlegging incidents that took place around Gloucester in the 1920s. In his history of Eastern Point, Joseph E. Garland describes the situation:

> The coast…of Cape Ann with its myriad coves, rivers, inlets, marshes, secret places, wharves and maritime sophistication came alive between sundown and sunup during Prohibition, and all this activity was spiced with bursts of melodrama, Coast Guard chases, gun battles, rammings, burnings, mysterious explosions, scuttlings, highjackings and piracy.

The Bootleggers, Cape Ann Granite, and *Hodgkin's House, Cape Ann, Massachusetts,* along with other oils dating from the 1920s, illustrate Hopper's direct painting technique. Here is how he described his approach:

> I have a very simple method of painting. It's to paint directly on the canvas without any funny business.

In the course of his lifetime, the surface texture of Hopper's canvases would become smoother, less worked up than is the case with his Gloucester oils. "In his later work," write the authors of *Techniques of the Great Masters of Art,* "Hopper created a transparent surface by building up the paint surface in thin layers and scraping down and repainting." This approach would prove ideal for handling the light and landscape of Cape Cod.

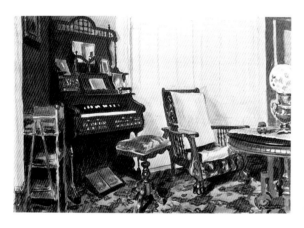

MRS. ACORN'S PARLOR, 1926
Watercolor on paper, 14 x 20 inches
The Museum of Modern Art, New York
Gift of Abby Aldrich Rockefeller

Rockland, Portland, and Cape Elizabeth

In the 1920s Hopper made several trips to Maine, including one in 1926 that landed him in the mid-coast city of Rockland, just south of Camden. While there, he painted a rare interior, *Mrs. Acorn's Parlor,* and a picture of a derelict boardinghouse which he called "The Haunted House." **15**

At the Rockland docks Hopper discovered trawlers, kin to those he had painted in Gloucester in 1923. Named after birds—*Widgeon, Teale, Osprey*—these ungainly fishing vessels proved fitting subjects for an artist who in his youth had considered becoming a naval architect. Hopper painted capstans, pulleys and smokestacks with as much care as he did cornices, gables and chimneys.

While he was summering in the Portland area in 1927, several buildings in the city itself struck Hopper's fancy, including the custom house and the Libby house, the latter a mansion designed in the manner of an Italian villa by Connecticut architect Henry Austin in the late 1850s. Now restored and renamed "Victoria Mansion," the

Libby house exemplifies what one critic has termed those "melancholy relics of the Age of Innocence" which Hopper was consistently drawn to paint. In this regard, his architectural appetite resembled that of an artist of a somewhat different ilk, Charles Addams, who chose similar "spooky" houses as the settings for his macabre cartoons.

By the time he visited Portland Head and nearby Cape Elizabeth in 1927, Hopper had already painted his fair share of lighthouses. There was Squam Light near Gloucester, the Monhegan Lighthouse, and the Eastern Point Light on Cape Ann. While they proved excellent subjects—as did the Highland Light in North Truro on Cape Cod, which Hopper painted in 1930—none had quite the dramatic height and picturesque setting of the Portland Head Light or Two Lights on Cape Elizabeth.

Hopper chose to paint several different views of these impressive beacons, working both from a distance, to heighten the panoramic quality of the settings, and in close, to focus on the architecture of adjoining or nearby structures. Thus, *Lighthouse and Buildings, Portland Head* is composed in the manner of a picture **13** postcard, while *Captain Strout's House, Portland Head,* 1927, features the keeper's quarters, in the process cropping the lighthouse in the background.

Hopper's views of Two Lights on Cape Elizabeth are even more varied than those of Portland Head. He painted the lighthouse several times from below, emphasizing its hilltop setting, but he also made studies of its base. The architecture of a nearby Coast Guard station and what Hopper called "the house of the fog horn" also attracted **12** him. On a return visit in 1929, he painted *The Lighthouse at Two Lights,* an oil, perhaps his most widely known lighthouse painting, as it appears on a 1970 U.S. postage stamp.

10 A later lighthouse picture, *Five A.M.,* 1937, represents what is perhaps Hopper's most unusual treatment of the subject. In a letter dated July 12, 1939, the artist explained the genesis of this otherworldly landscape:

> ...I think [the idea for this picture] was suggested by some things that I had seen while travelling on the Boston, New York boats on Long Island Sound. The original impression grew into an attempted synthesis of an entrance to a harbour on the New England coast.

Some critics have read Hopper's lighthouses as architectural manifestations of the theme of loneliness found elsewhere in his art. Gail Levin even suggests a personal—and physical—relationship between artist and subject: "He [Hopper] was nearly six feet five inches tall and perhaps felt a special affinity to this genre of architecture, which, like him, stood apart, detached from the rest of the world." I'd like to think that Hopper also was drawn to lighthouses simply because they are visually arresting structures and, quite literally, houses of light.

In a conversation with Katharine Kuh published in 1962, Hopper explained some of his reasons for going to Cape Cod:

> I chose to live here because it has a longer summer season. I like Maine very much, but it gets so cold in the fall. There's something soft about Cape Cod that doesn't appeal to me too much. But there's a beautiful light there—very luminous—perhaps because it's so far out to sea; an island almost.

The Hoppers first rented houses in the South Truro area, then in 1933 bought land there and subsequently designed and had built a simple shingled studio house.

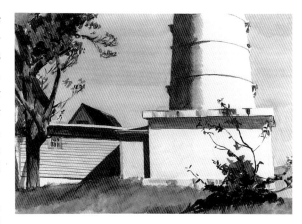

[LIGHT AT TWO LIGHTS], 1927
Watercolor on paper, 13¹⁵/₁₆ x 19 ¹⁵/₁₆ inches
Collection of Whitney Museum of American Art, New York
Josephine N. Hopper Bequest 70.1143

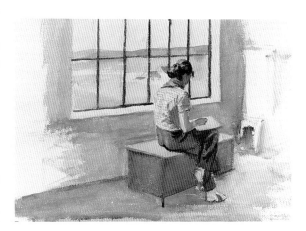

[JO SKETCHING IN THE TRURO HOUSE], c. 1934-1938
Watercolor on paper, 13¹⁵/₁₆ x 20 inches
Collection of Whitney Museum of American Art, New York
Josephine N. Hopper Bequest 70.1106

Cape Cod

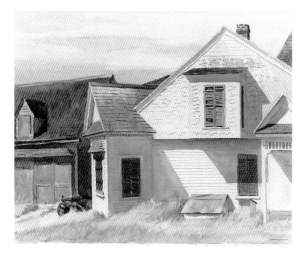

HOUSE ON PAMET RIVER, 1934
Watercolor on paper, 21¹³/₁₆ x 26 ¹³/₁₆ inches
Collection of Whitney Museum of American Art, New York
Purchase 36.20

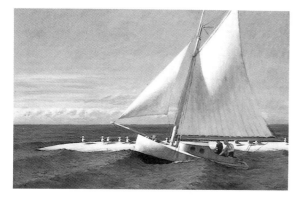

THE MARTHA McKEAN OF WELLFLEET, 1944
Oil on canvas
32 x 50 inches
Thyssen-Bornemisza Collection
Photography courtesy of Art Resource

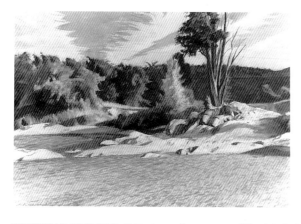

WHITE RIVER AT SHARON, 1937, Watercolor on paper, 19³/₈ x 27½ inches
National Museum of American Art, Washington, D.C., Gift of the Sara Roby Foundation, Photograph courtesy of Art Resource, New York

Aside from trips to Vermont, the West Coast, Mexico and the Southwest, Hopper would spend a good part of nearly every summer on the Cape from 1930 until his death in 1967.

Cape Cod represented new painting territory for the artist. The landscape differed considerably from that of Maine or Cape Ann. In place of rocky coastline and picturesque harbors, there were dunes and rolling hills. Hopper wasted no time in tackling these subjects: *Corn Hill* and *Hills, South Truro* date from his first summer **22, 21** on the Cape, in 1930.

In his praise of the latter painting, Guy Pène du Bois attests to Hopper's immediate and profound grasp of this new terrain. *"Hills, South Truro,"* du Bois wrote, "brings us back to those moments, they are rare enough, when we have felt the presence of some power beyond our strength, of that cosmic order or harmony existing beyond the chaos of our little lives."

Just as transcendental in its effect, *The Camel's Hump,* an oil painted a year later, **23** in 1931, captures the essence of the Cape landscape, what Jo Hopper once called the "wonderful land of bare green sandy hills." The painting is composed of zones of color and light which lend the view that "harmony" which appealed to du Bois. Shapes created by sun and shadow and patches of sand give the humped ridge in the middle distance the appearance of something alive. We are not that far from Elihu Vedder's famous dunescape, *The Lair of the Sea Serpent.*

The architecture of Cape Cod also proved quite different from what Hopper had worked with in the past. While he would occasionally choose to paint grander dwellings, such as summer cottages in Wellfleet, for the most part Hopper turned his attention to the shacks, barns, farmhouses and simple pitch-roofed houses which give the Cape its rural character. *Captain Kelly's House* and *New York, New Haven and* **28,** p. 17 *Hartford,* both 1931, *Cape Cod Afternoon,* 1936, and *Shacks at Pamet Head,* 1937, **31, 26** are among his most accomplished works in this genre.

Also notable are the series of studies of Burly Cobb's house and barns in South Truro, which Hopper executed in 1930-31. The artist was particularly drawn to the shadow play of evening light and how roof lines cut across and into the hilly terrain.

Hopper had drawn and painted sailboats since he was a young man (he even built one in his teens), but on the Cape this subject became a significant part of his repertoire. On the strength of *Ground Swell,* a 1939 oil, John Wilmerding included **19** Hopper in his *History of American Marine Painting.* Critic Robert Hughes, reviewing Hopper's retrospective at the Whitney in 1980, picked out *The Martha McKean of Wellfleet,* a 1944 oil, for special praise: "It's all there," he wrote, "fragile but immemorial, as permanent as the way the gulls on the sandspit face into the light."

In a canvas like *The Lee Shore,* 1941, Hopper's love of the open water is most **20** evident. The 1935 watercolor *Yawl Riding a Swell,* while evoking the pleasures of **18** height-of-summer sailing, also conjures up the perils of the sea. The small two-masted vessel tips precariously forward; one feels the swelling wave may bear the boat down into the sea. According to Gail Levin, Hopper "gave up sailing because his wife insisted he was too good a man to lose that way."

In the summers of 1935–1938 the Hoppers went on excursions to Vermont. In **14** the latter two years they stayed in the town of South Royalton, just north and west of White River Junction. There Hopper did some of his purest landscapes, all water-

colors, several of them studies of the gravel bars and curving bends of the White River where it passes through Royalton and Sharon.

If the trees in some of his Cape Cod oils at times seem prop-like, in the Vermont watercolors they have an individual liveliness, a windswept feeling that gives the illusion we are looking at some of the views from a passing car. Hopper also painted a Vermont sugar house; he couldn't resist the planar arrangement of its several roofs and the way in which the building is set solidly into the landscape.

Beginning in the late 1930s, Hopper's Cape Cod paintings take a turn for the psychological. What poet and essayist Mark Strand calls "the loneliness factor" in Hopper's work comes to the fore. In introducing figures into his New England pieces, the artist entered the charged theatrical arena of Eugene O'Neill. At the same time he painted more interiors, and his houses grew smaller and slipped deeper into the surrounding woods.

Hopper also increasingly worked from memory, in the studio, away from the real
32 world. Thus, he notes that *Cape Cod Evening,* 1939, was "no transcription of a place but [was] pieced together from sketches and mental impressions of things in the vicinity." The doorway, he tells us, was borrowed from a house in Orleans, a town 20 miles distant from South Truro; and "the dry, billowing grass" in the painting could be seen from his studio window in late summer or autumn. Hopper's esthetic brings to mind something Wallace Stevens wrote: "Reality is not what it is. It consists of the many realities which it can be made into."

Nearly all of the oils from Hopper's later years are composites. Thus, the pumps
29 in *Gas,* 1940, are based on studies of the real thing, but the filling station itself is an invention—made up, Hopper told Goodrich, "out of parts of several." No matter that the station is lit up like day, that the attendant is dressed neatly in tie and vest: the blood-red pumps and the looming wall of dark trees intimate if not death then at the very least the fear of a traveler on a lonely Cape Cod road.

33 The shadowy edifice depicted in *Rooms for Tourists,* 1945, also suggests a certain evil atmosphere—it puts me in mind of the house in Alfred Hitchcock's *Shadow of a Doubt* where the widow-killer, Uncle Charlie, played by Joseph Cotten, takes refuge. While Hopper modeled the house on an actual hotel in Provincetown, he obviously took pleasure in heightening the building's nighttime countenance, the dark awnings, the eerie glow of artificial light.

34 By contrast, the house in *High Noon,* 1949, brings to mind an observation in Charles Dickens' *American Notes* (1842): "Every house is the whitest of the white…every fine day's sky the bluest of the blue…All the buildings looked as if they had been built and painted that morning." Goodrich reports that Hopper constructed a cardboard version of the house in *High Noon* and "placed it in the sunlight to get the exact pattern of light and shadows." The artist worked out of his head but also out of a profound devotion to verisimilitude.

In *High Noon,* the woman in the doorway is modeled on the artist's wife; in fact, Jo posed for many of the female figures in Hopper's paintings. There is a touch of eroticism in the way in which the woman appears to be opening her house dress to expose her body to the noonday sun—a rare touch for Hopper, who generally
p. 16 eschewed such sensualism in his nudes. In a later piece, *A Woman in the Sun,* 1961,

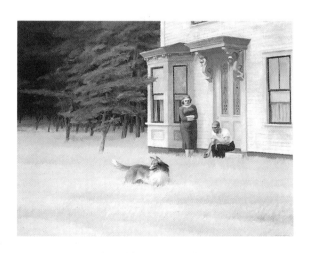

CAPE COD EVENING, 1939
Oil on canvas, 30¼ x 40¼ inches
National Gallery of Art, Washington, D.C.
John Hay Whitney Collection

Hopper depicts an older Jo in a rather cool anatomical manner, this despite the fact that her naked body is bathed in strong South Truro light. While several critics have read in this painting a version of the Annunciation of the Virgin Mary, Hopper himself called the woman "a wise tramp."

Jo Hopper kept careful records of her husband's paintings, and often jotted down descriptions of them, including technical details. In the notes for *Cape Cod Morning,* **30** 1950, for instance, we read that Hopper used Winsor & Newton oils and that the painting "went off speedily, no interrupting, from sketches." The few words devoted to the figure in the picture—"Blondish housewife (appraising weather) in pink cotton dress"—contrasts sharply with the sometimes lengthy interpretations critics and art historians have offered regarding the disposition of this lone woman looking into the sun.

The geometry found in Hopper's work, from his earliest architectural studies to the interior constructs of his last years, has been remarked upon by many critics and historians. Goodrich recounts that Hopper didn't much like being placed in the same company with abstract-geometric painters. "When I told him [Hopper] that in a lecture I had used a slide of *High Noon* together with a Mondrian," Goodrich reports, "his only comment was, 'You kill me.'"

Yet there's no denying the resemblance. *Rooms by the Sea,* 1951, which Gail **35** Levin discovered was an "adjusted" view of the inside of Hopper's South Truro house, is by and large a formal geometric study of light and shadow. The painting brings to mind the spare rooms of Andrew Wyeth as much as it does the surreal juxtapositions of René Magritte, who no doubt would have admired the way Hopper brought the sea right up to the door.

To a certain extent, *Rooms by the Sea* and *Sun in an Empty Room,* 1963, sum up Hopper's spirit and esthetic in the same way the late work of Mark Rothko did his; in both cases, the implication is that the artist could go no further in his exploration of psychological space. Hopper had long been fascinated by empty rooms; he recounted to Brian O'Doherty how, at the Chase School, he, du Bois, Kent and others had "debated what a room looked like when there was nobody to see it, nobody looking in even." Such speculation, carried out over a lifetime, led to the simplest of compositions—and to canvases that haunt by their profound evocation of isolation.

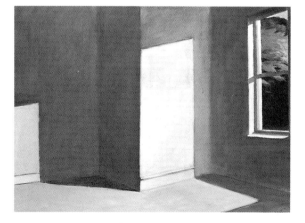

SUN IN AN EMPTY ROOM, 1963
Oil on canvas
28¾ x 39½ inches
Private collection

A WOMAN IN THE SUN, 1961
Oil on canvas, 40 x 60 inches
Collection of Whitney Museum of American Art, New York
50th Anniversary Gift of Mr. and Mrs. Albert Hackett
in honor of Edith and Lloyd Goodrich 84.31

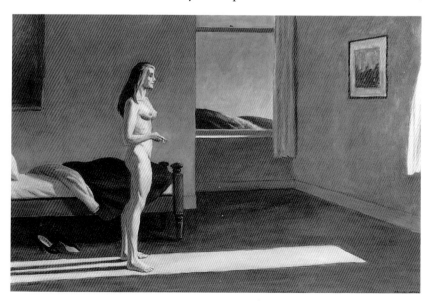

In an article on Hopper, one of his contemporaries, painter Charles Burchfield, observed that "his art seems to have had few antecedents and, like most truly individual expressions, will probably have no descendants." Such a statement underlines the difficulty art historians and critics have had in placing Hopper neatly into the scheme of American art.

Commentators have noted Hopper's kinship to certain schools of painting—the Regionalists, the Precisionists, the American Scene painters—only to conclude that he doesn't fit into any of them. The label "realist" is a constant, but it's often qualified, as when art historian Donelson F. Hoopes uses the adjective "romantic" to describe Hopper's brand of realism.

Some writers have related Hopper's realism to that of photography. He was known to have admired the Civil War photographer Mathew Brady ("the pictures aren't cluttered up with detail," Hopper said of his photographs, "you just get what is important") and the French camera artist Eugène Atget; and there's a study that links him to Walker Evans. I would proffer Paul Strand as another relative: in his photograph *Town Hall, New England*, 1946, he crops the building in much the same way Hopper did some of his structures.

A number of writers have gone overboard in emphasizing the so-called "ugly" aspect of Hopper's work—"The Hideous Beauty of American Places" is the title of a recent essay on his art—while others have read loneliness into everything he painted, an angle the artist himself felt was overplayed. In my mind, to take such tacks is to overlook a large body of Hopper's work, in particular the many radiant New England watercolors and the magnificent lighthouse oils and sailing pictures.

One of the most enduring and poetic appreciations of Hopper's work appears in Alexander Eliot's *Three Hundred Years of American Painting*. Eliot's train analogy is especially fitting when one considers that railroad tracks run across the foreground of many of Hopper's pictures:

> Looking at his paintings is like drifting past people's backyards on a slow local, in a state of intimate awareness. Slowly the train glides on, through dreams and decades. The tall, stooped conductor keeps silent. In silence he gestures toward the windows, and America beyond.

New England comprised a large segment of that America toward which Hopper gestured in his art. In a manner of speaking, his paintings help define the region—we continue to speak of a "Hopper house" or a "Hopper sky"—and one feels the lighthouses are kept up in part because of the glory he brought to them.

Poet Richard Wilbur once wrote that, "In part, at least, all men approach the landscape self-centeredly or self-expressively, looking for what agrees with their temperaments, what seems to embody their emotions, what suits them as décor or theatre of action." On the coast of Maine, in the city of Gloucester, among the hills of Vermont and Cape Cod, Hopper found the landscapes to suit his sensibility. He looked long and hard, studying the lay of the land and how the houses handle light at different times of day. He enlisted his eye, heart and head in responding to this world; and we in turn must enlist our own to appreciate the genius of Edward Hopper and his vision of New England.

Carl Little
Mt. Desert, Maine

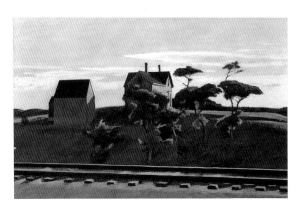

NEW YORK, NEW HAVEN, AND HARTFORD, 1931
Oil on canvas, 32 x 50 inches
© 1993 Indianapolis Museum of Art
Emma Harter Sweetser Fund

1
GLOUCESTER HARBOR, 1912
Oil on canvas
26 x 38 inches
Collection of Whitney Museum of American Art, New York
Josephine N. Hopper Bequest 70.1204

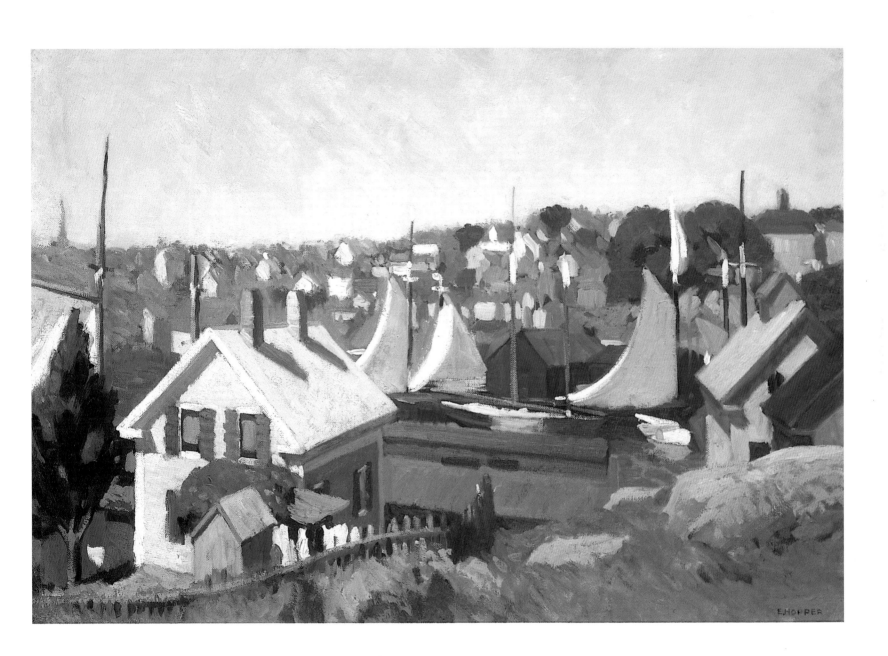

2
ITALIAN QUARTER, GLOUCESTER, 1912
Oil on canvas
23⅜ x 28½ inches
Collection of Whitney Museum of American Art, New York
Josephine N. Hopper Bequest 70.1214

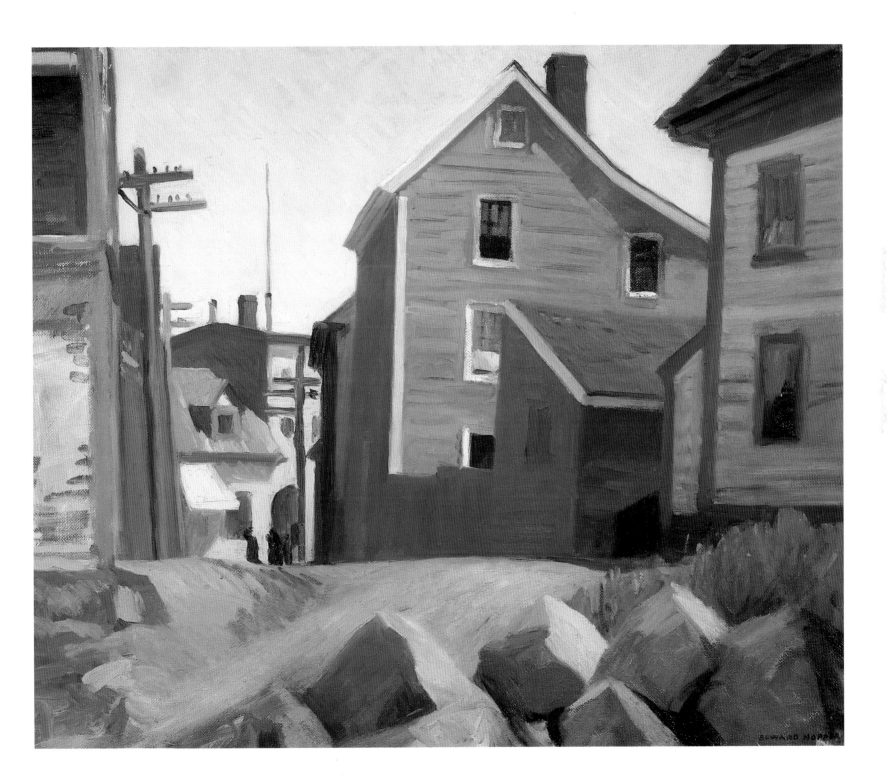

3
FREIGHT CARS, GLOUCESTER, 1928
Oil on canvas
29⅛ x 40¼ inches

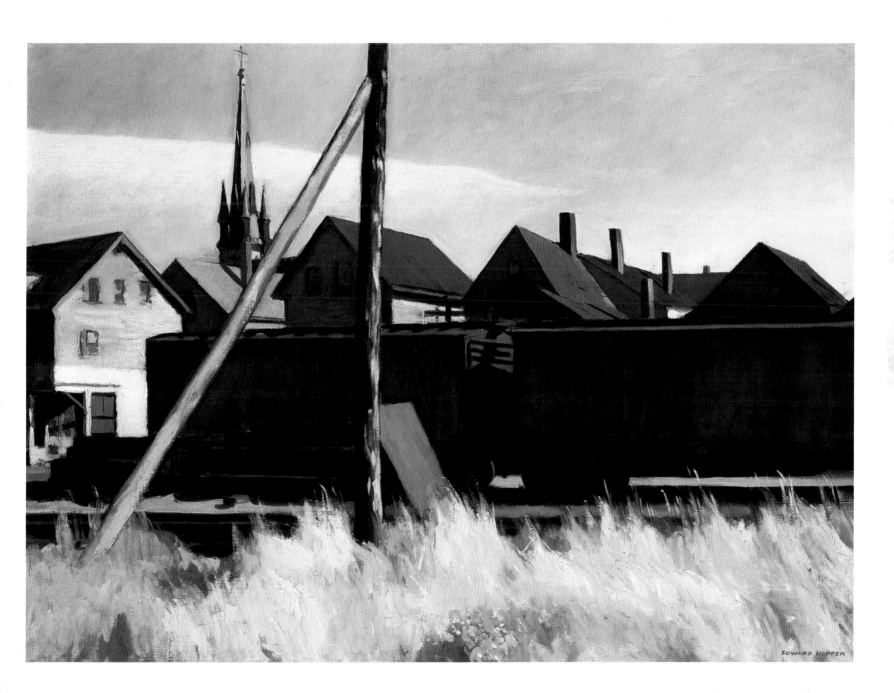

4
BOX FACTORY, GLOUCESTER, 1928
Watercolor on paper
14 x 20 inches
The Museum of Modern Art, New York
Gift of Abby Aldrich Rockefeller

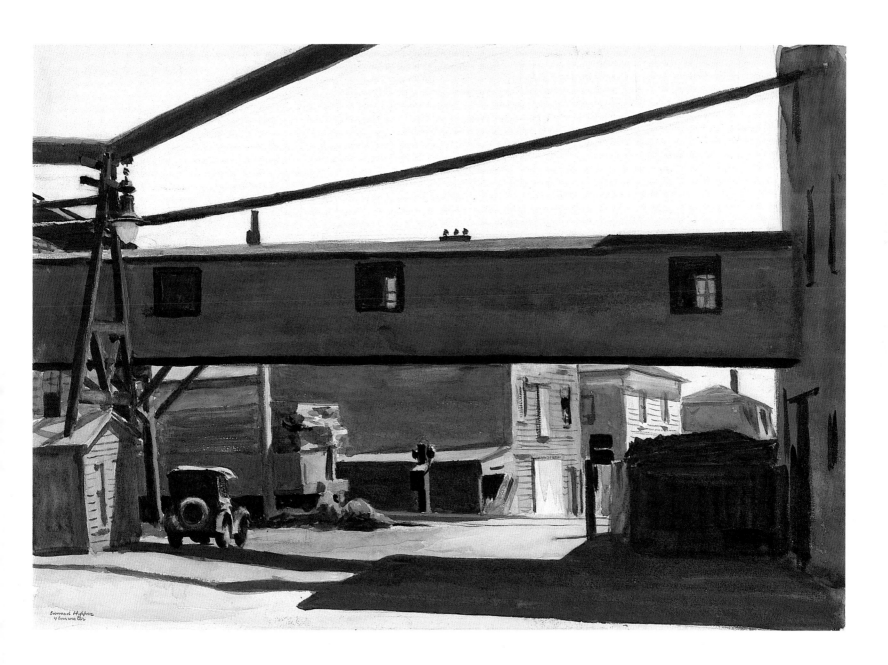

5
FUNNEL OF TRAWLER, 1924
Watercolor on paper
13¼ x 19¼ inches
Photograph courtesy of Richard York Gallery, New York

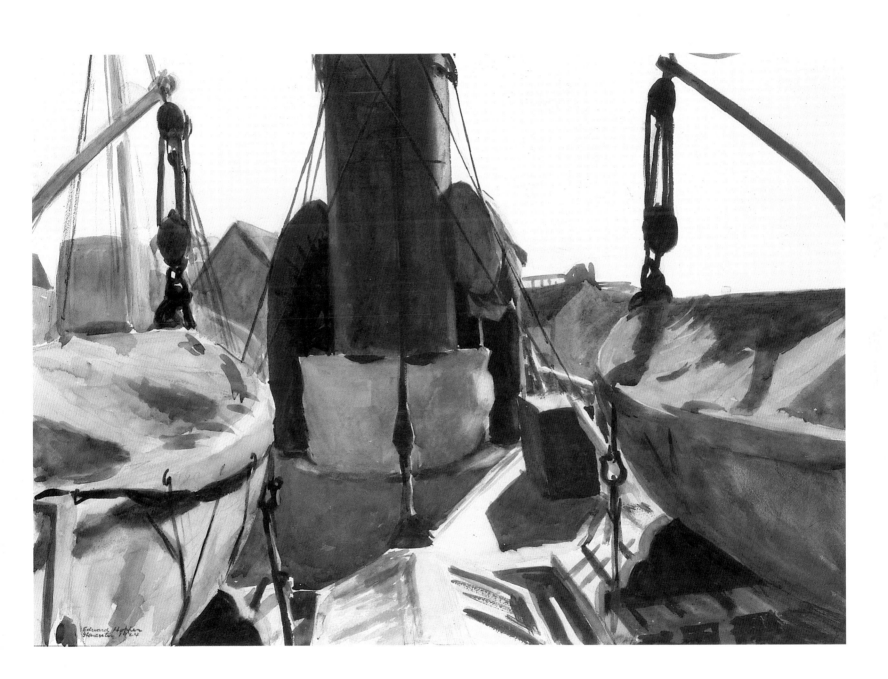

6
[CARS AND ROCKS], 1927
Watercolor on paper
13⅞ x 20 inches
Collection of Whitney Museum of American Art, New York
Josephine N. Hopper Bequest 70.1104

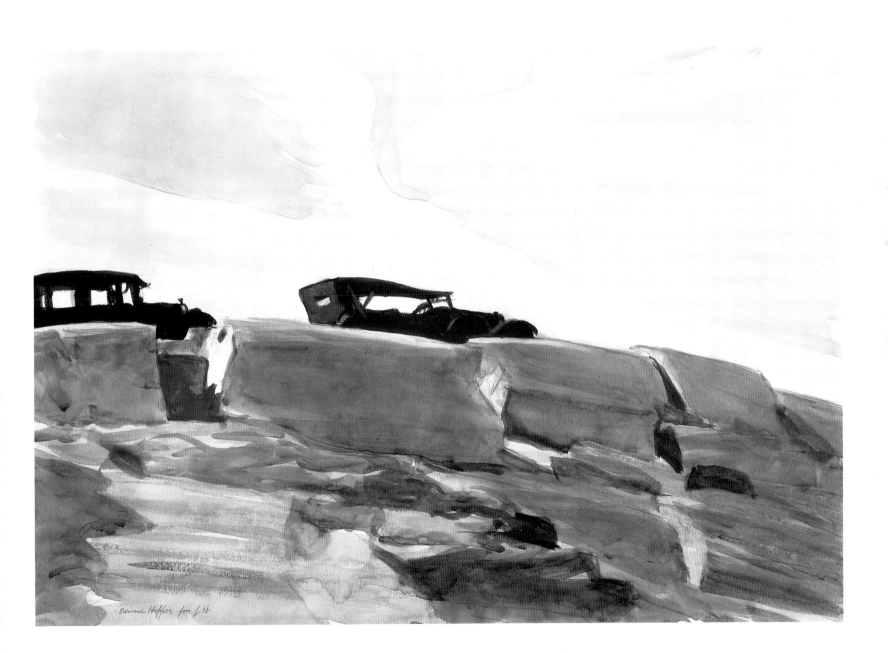

Edward Hopper for J. H.

7
[BLACKHEAD, MONHEGAN], 1916–19
Oil on wood
9½ x 13 inches
Collection of Whitney Museum of American Art, New York
Josephine N. Hopper Bequest 70.1317

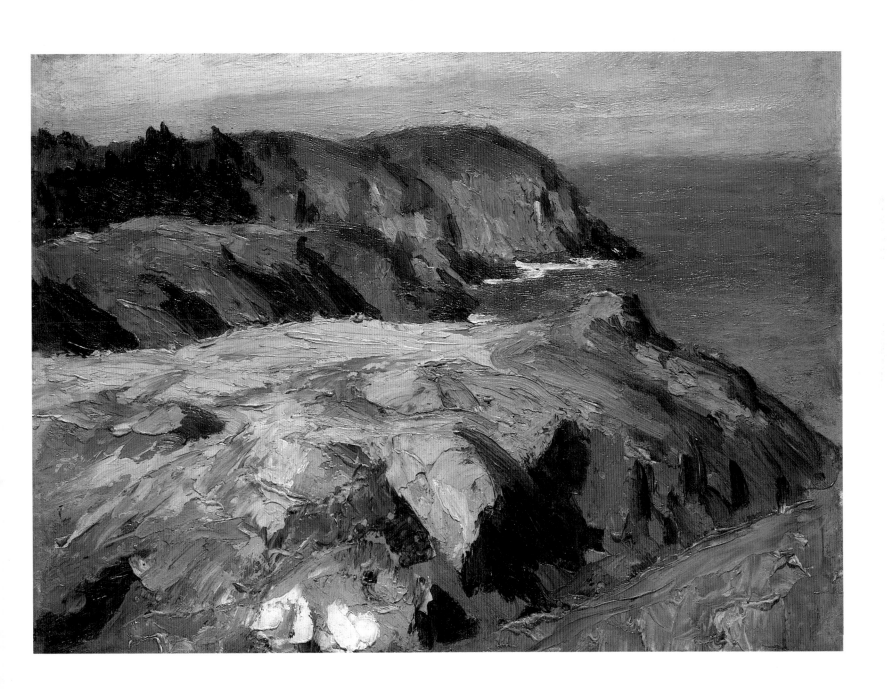

8
THE DORY (TWO LIGHTS, MAINE), 1929
Watercolor and gouache over graphite on paper
$13\frac{7}{8}$ x $20\frac{1}{16}$ inches
The Nelson-Atkins Museum of Art, Kansas City, Missouri
Gift of Mrs. Louis Sosland

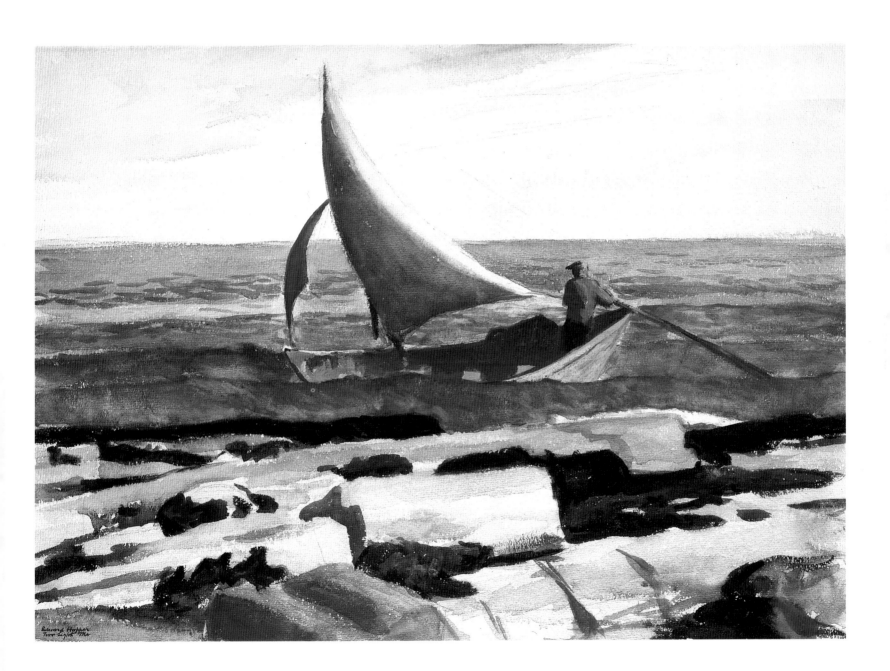

9
THE DORIES, OGUNQUIT, 1914
Oil on canvas
24 x 29 inches
Collection of Whitney Museum of American Art, New York
Josephine N. Hopper Bequest 70.1196

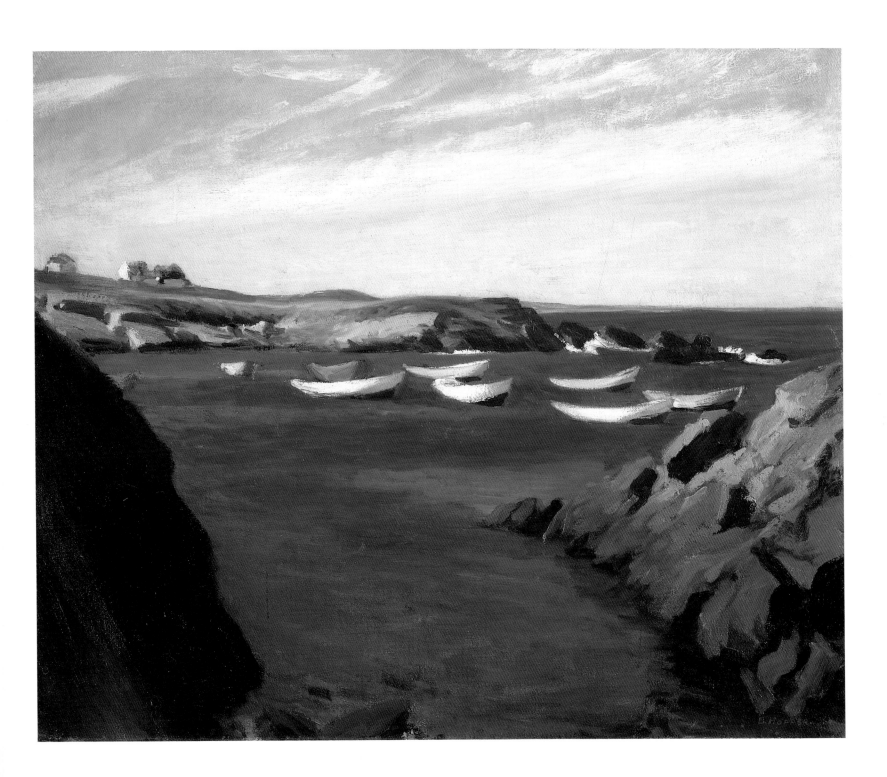

10
FIVE A.M., c. 1937
Oil on canvas
25 x 36 inches
Wichita Art Museum, Wichita, Kansas
The Roland P. Murdock Collection

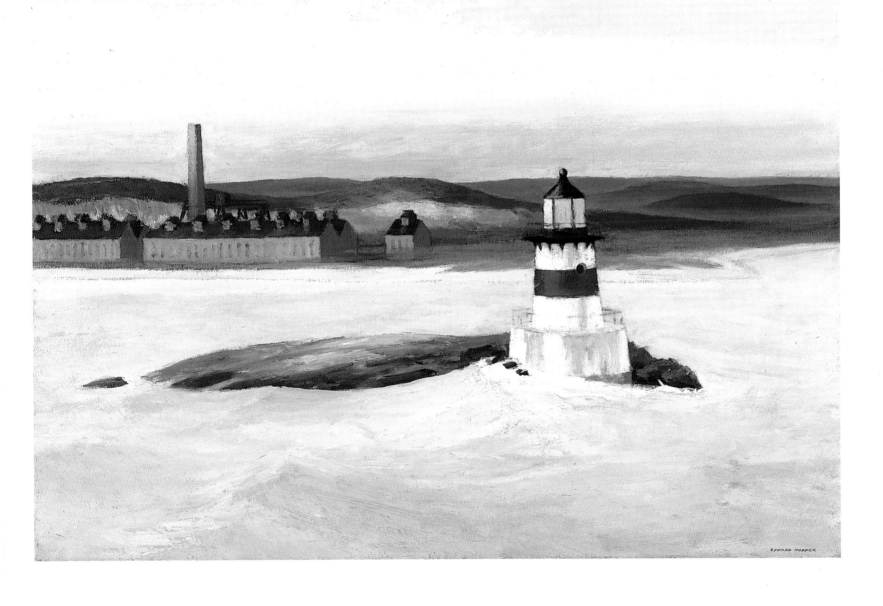

11
LIGHTHOUSE HILL, 1927
Oil on canvas
28¼ x 39½ inches
Dallas Museum of Art
Gift of Mr. and Mrs. Maurice Purnell

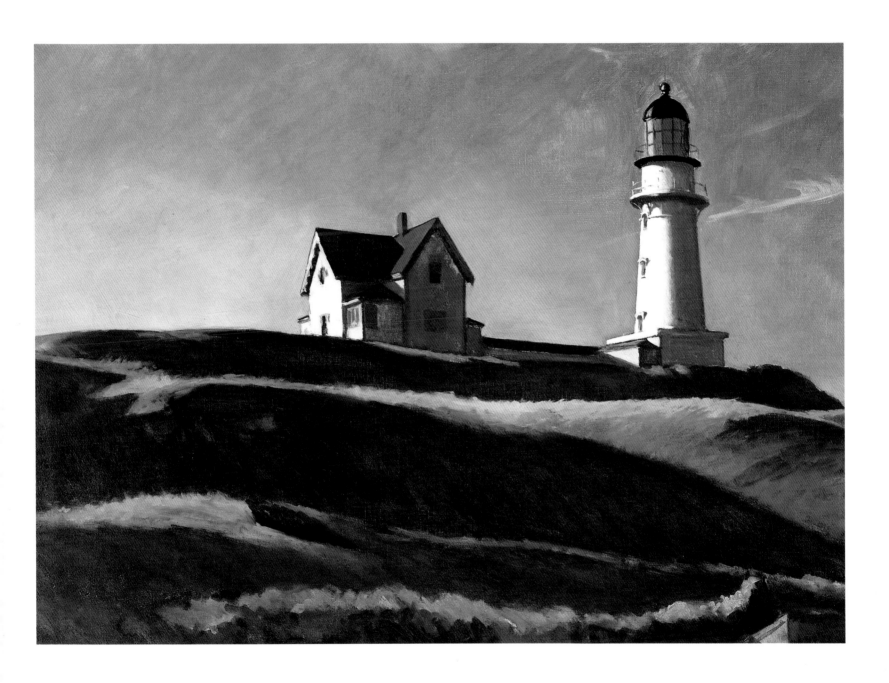

12
THE LIGHTHOUSE AT TWO LIGHTS, 1929
Oil on canvas
29½ x 43¼ inches
The Metropolitan Museum of Art
Hugo Kastor Fund, 1962 (62.95)

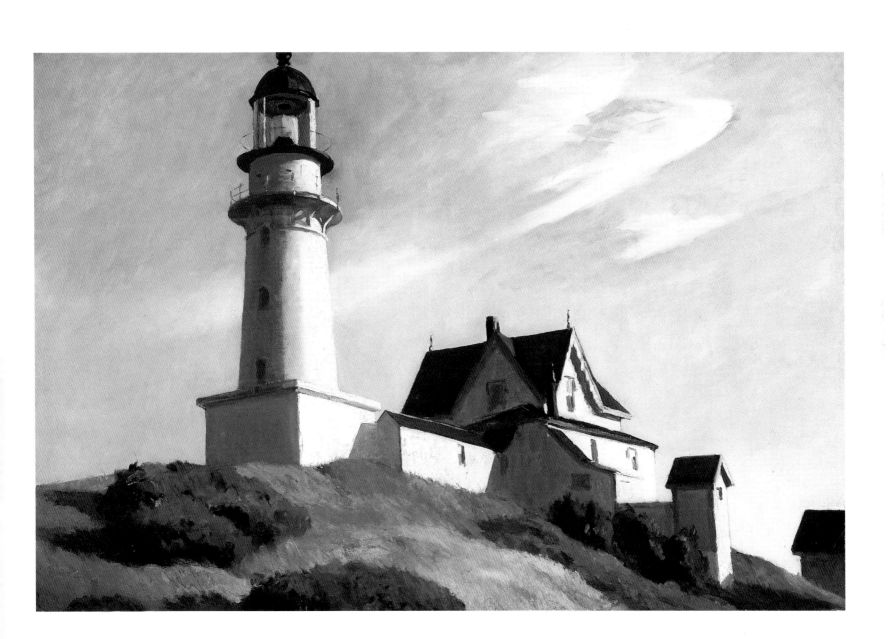

13
CAPTAIN STROUT'S HOUSE, PORTLAND HEAD, 1927
Watercolor
14 x 20 inches
Wadsworth Atheneum, Hartford, Connecticut
The Ella Gallup Sumner and Mary Catlin Sumner Collection

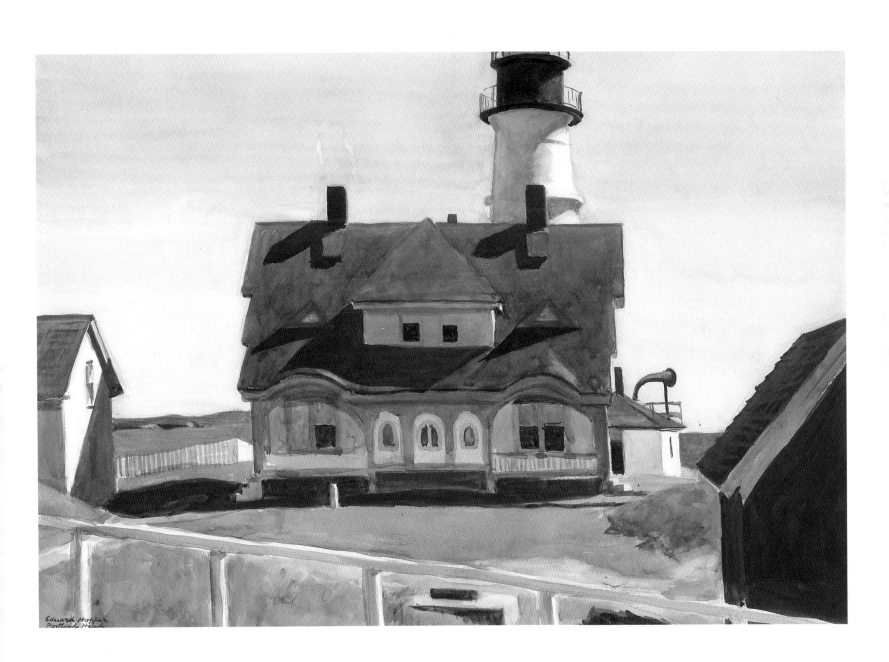

14
VERMONT HILLSIDE, 1936
Watercolor on paper
$20\frac{1}{8}$ x $27\frac{7}{8}$ inches
Courtesy of Spanierman Gallery, New York

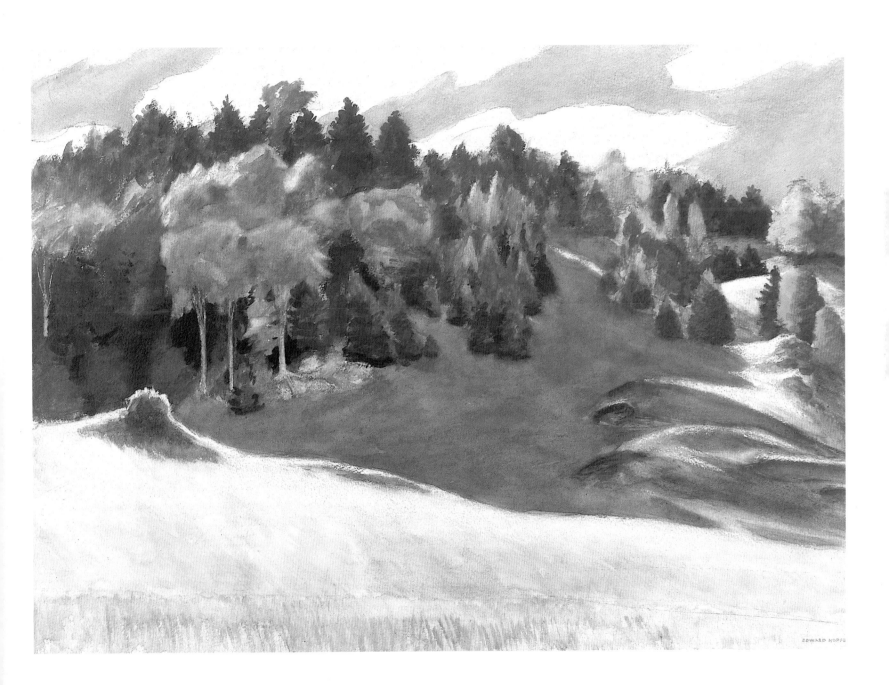

15
HAUNTED HOUSE, 1926
Watercolor
14 x 20 inches
William A. Farnsworth Library and Art Museum
Rockland, Maine

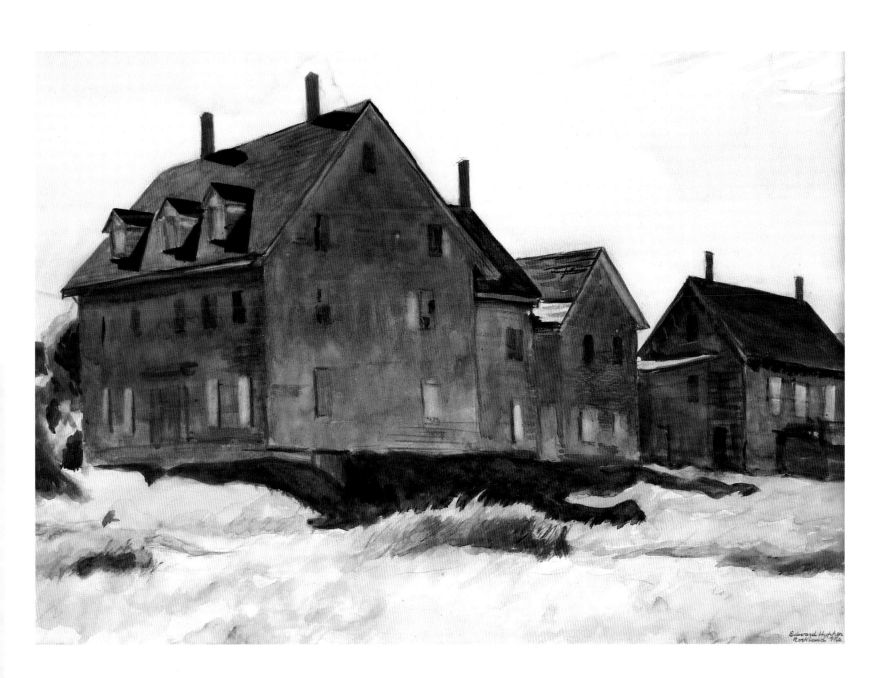

16
THE MANSARD ROOF, 1923
Watercolor over pencil
13¾ x 19 inches
The Brooklyn Museum 23.100
Museum Collection Fund

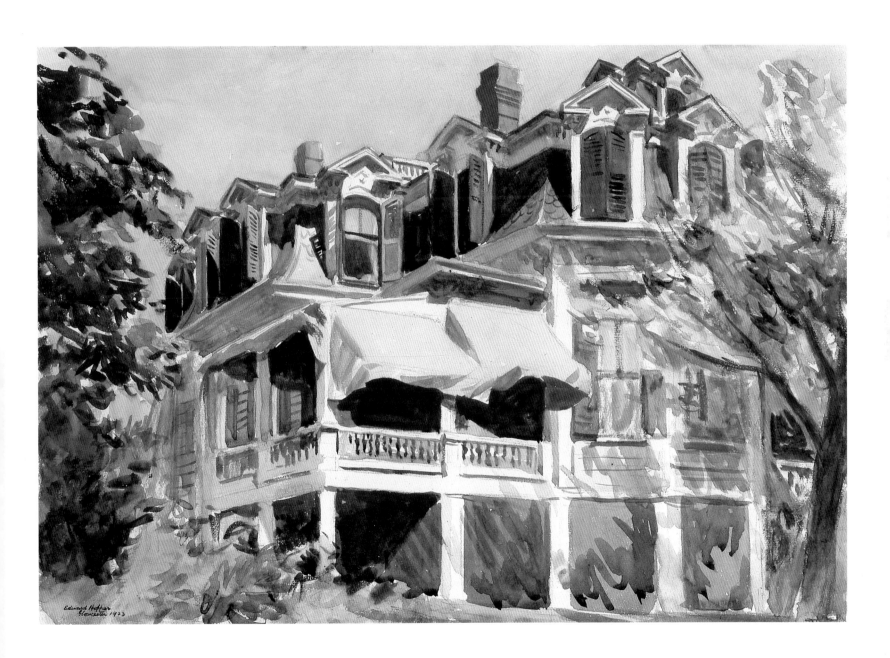

17
THE BOOTLEGGERS, 1925
Oil on canvas
30⅛ x 38 inches
The Currier Gallery of Art, Manchester, New Hampshire
Currier Funds 1956.4

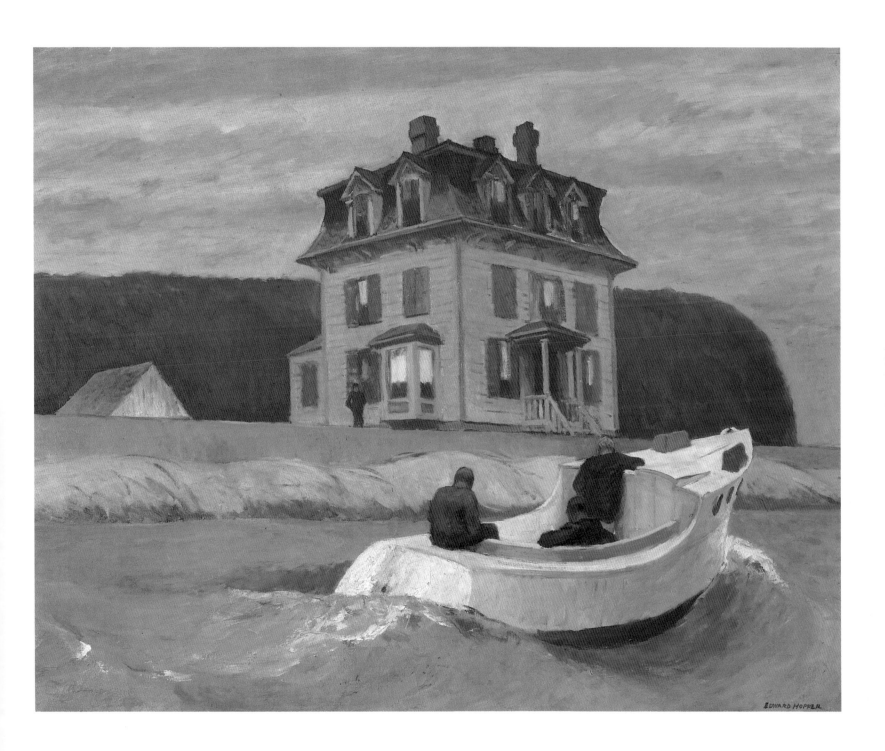

18
YAWL RIDING A SWELL, 1935
Watercolor over graphite on off-white wove paper
19⅞ x 27¾ inches
Worcester Art Museum, Worcester, Massachusetts

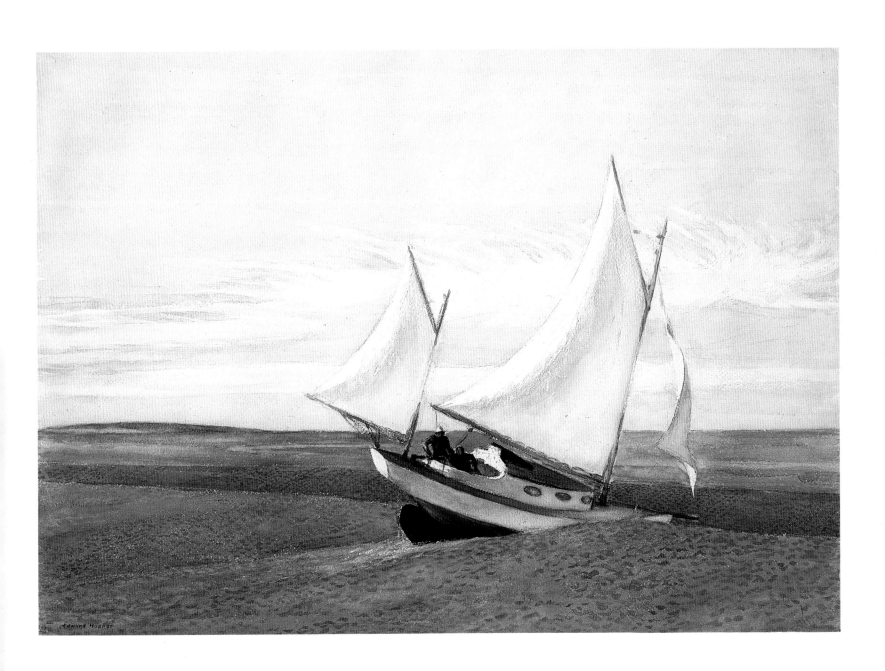

19
GROUND SWELL, 1939
Oil on canvas
36½ x 50¼ inches
In the collection of The Corcoran Gallery of Art
Museum Purchase, William A. Clark Fund

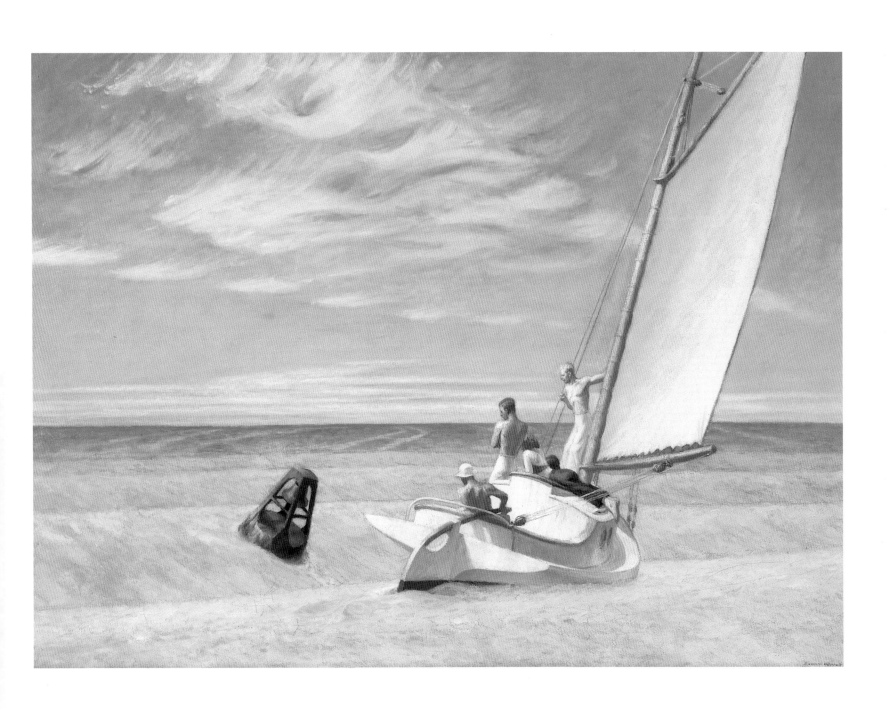

20
THE LEE SHORE, 1941
Oil on canvas
28¼ x 43 inches
Private collection
Photograph courtesy of Art Resource

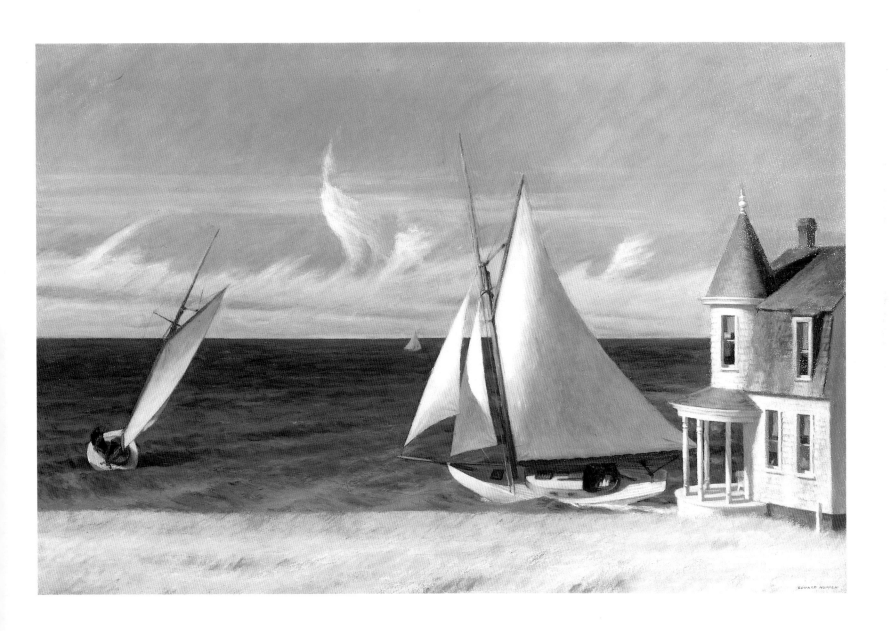

21
HILLS, SOUTH TRURO, 1930
Oil on canvas
27³⁄₈ x 43¹⁄₈ inches
The Cleveland Museum of Art
Hinman B. Hurlbut Collection, 2647.31

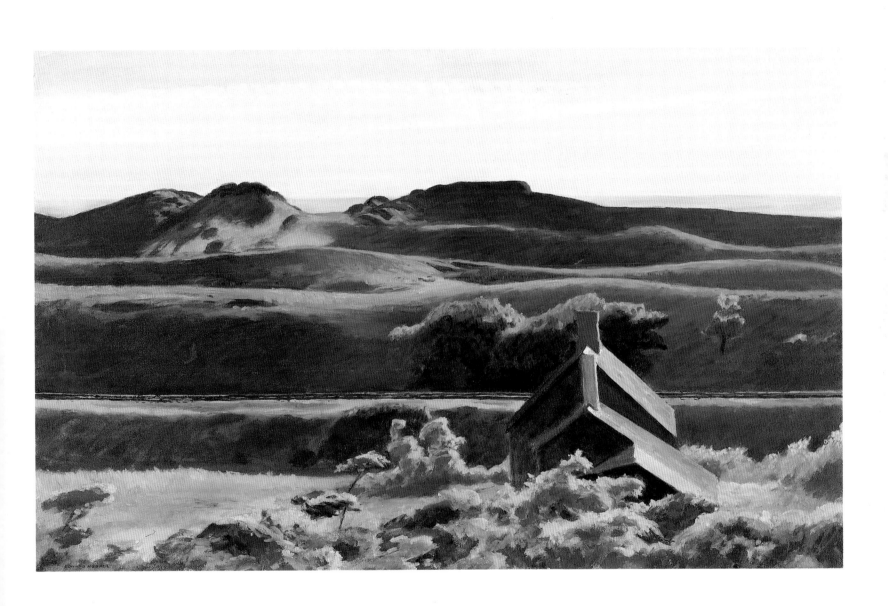

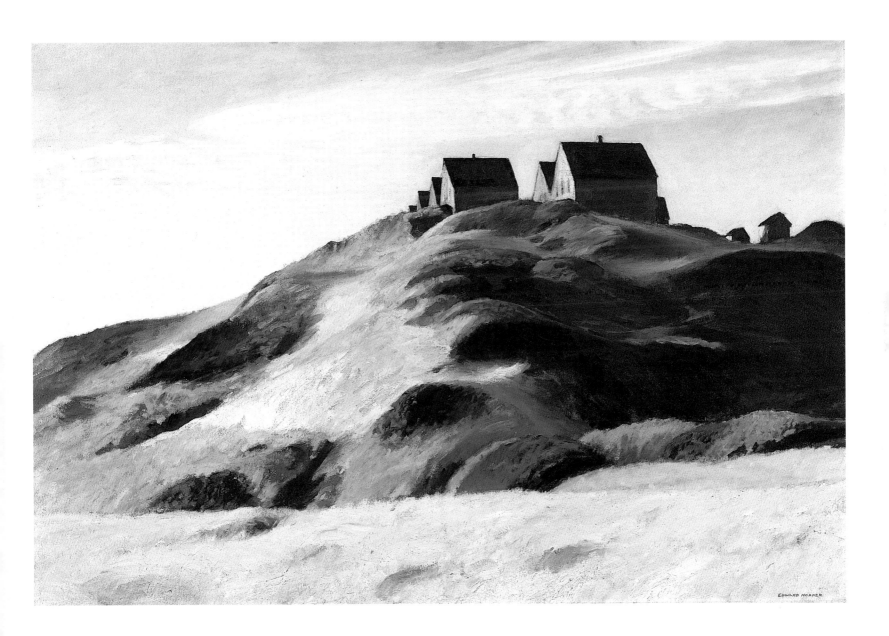

23
THE CAMEL'S HUMP, 1931
Oil on canvas
32¼ x 50¼ inches
Munson-Williams-Proctor Institute, Museum of Art
Utica, New York
Edward W. Root Bequest

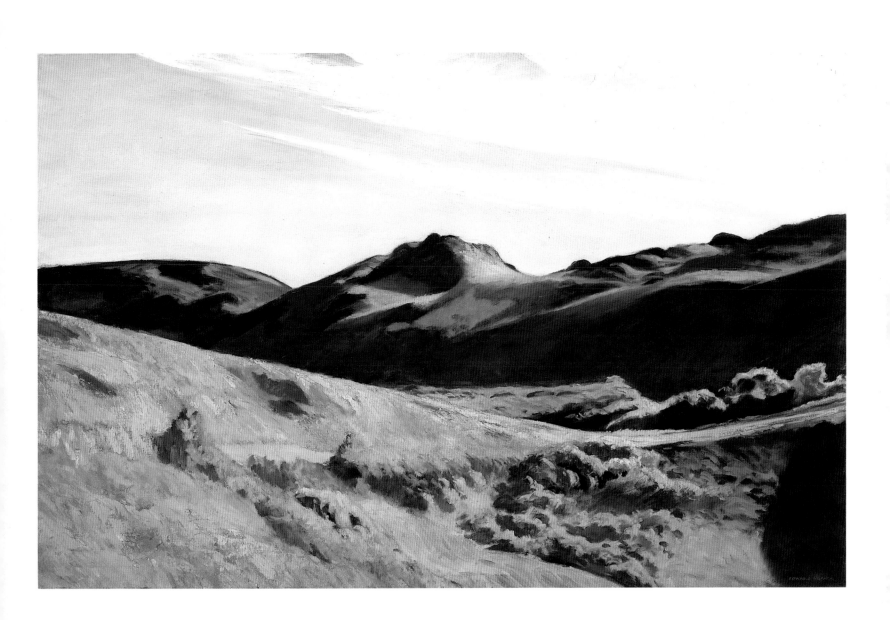

24
[COBB'S BARNS AND DISTANT HOUSES], 1930–1933
Oil on canvas
28½ x 42¾ inches
Collection of Whitney Museum of American Art, New York
Josephine N. Hopper Bequest 70.1206

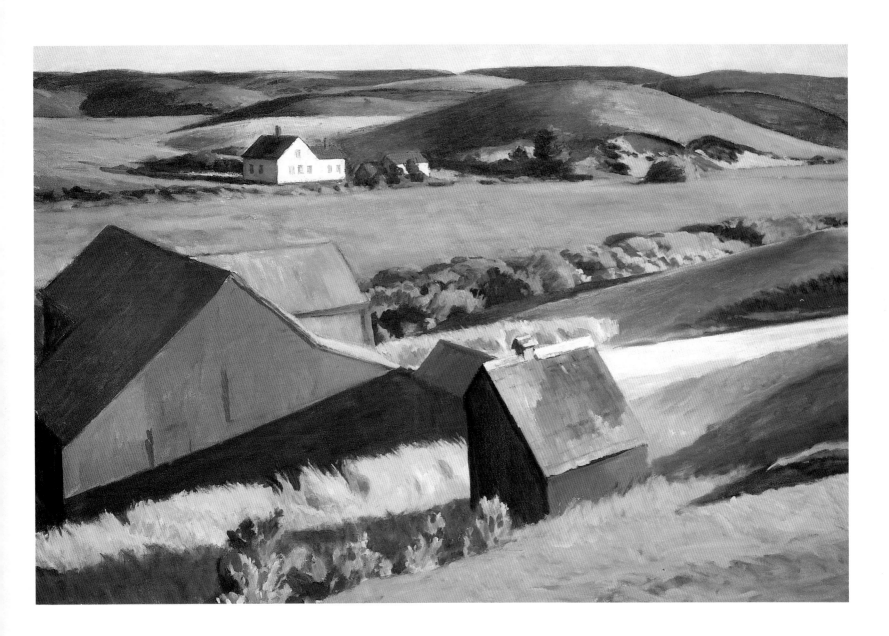

25
[COBB'S BARNS, SOUTH TRURO], 1930–1933
Oil on canvas
34 x 49¾ inches
Collection of Whitney Museum of American Art, New York
Josephine N. Hopper Bequest 70.1207

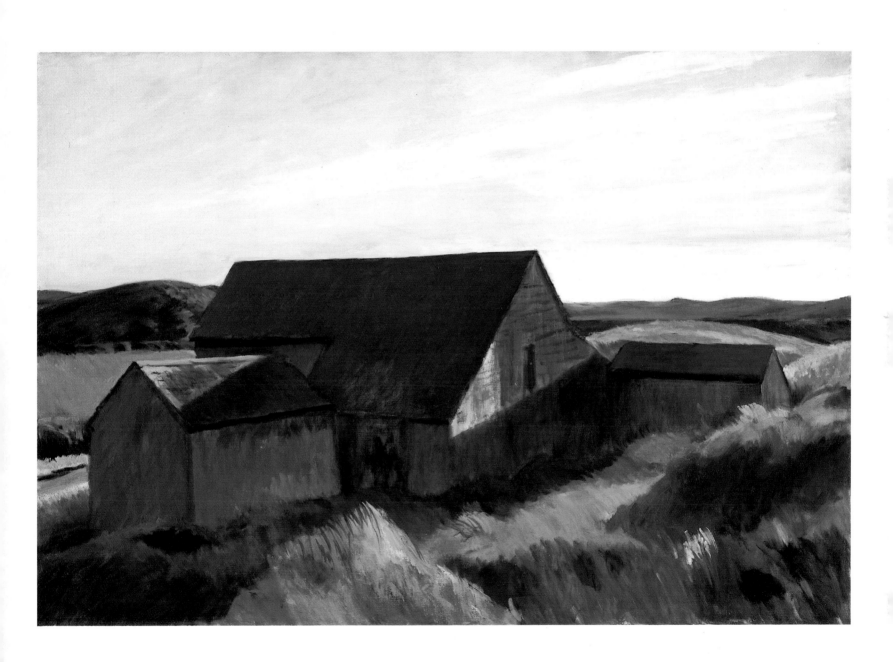

26
SHACKS AT PAMET HEAD, (Massachusetts), 1937
Watercolor on paper
20 x 22 inches
Private collection, New York
Photograph courtesy of Spanierman Gallery, New York

27
HIGH ROAD, 1931
Watercolor on paper
20 x 28 inches
Collection of Whitney Museum of American Art, New York
Josephine N. Hopper Bequest, 70.1163

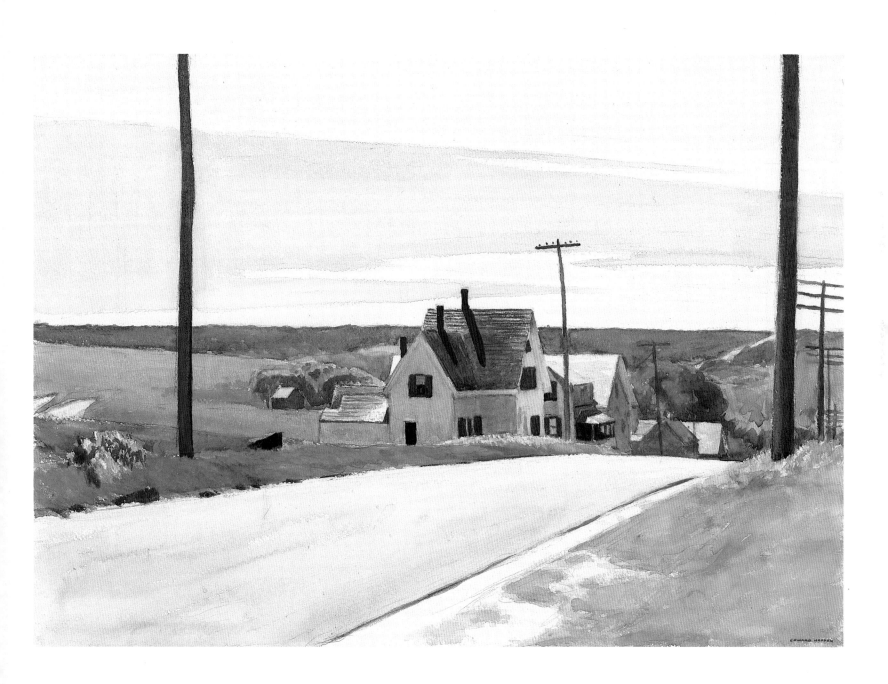

28
CAPTAIN KELLY'S HOUSE, 1931
Watercolor on paper
20 x 24⅞ inches
Collection of Whitney Museum of American Art, New York
Josephine N. Hopper Bequest 70.1160

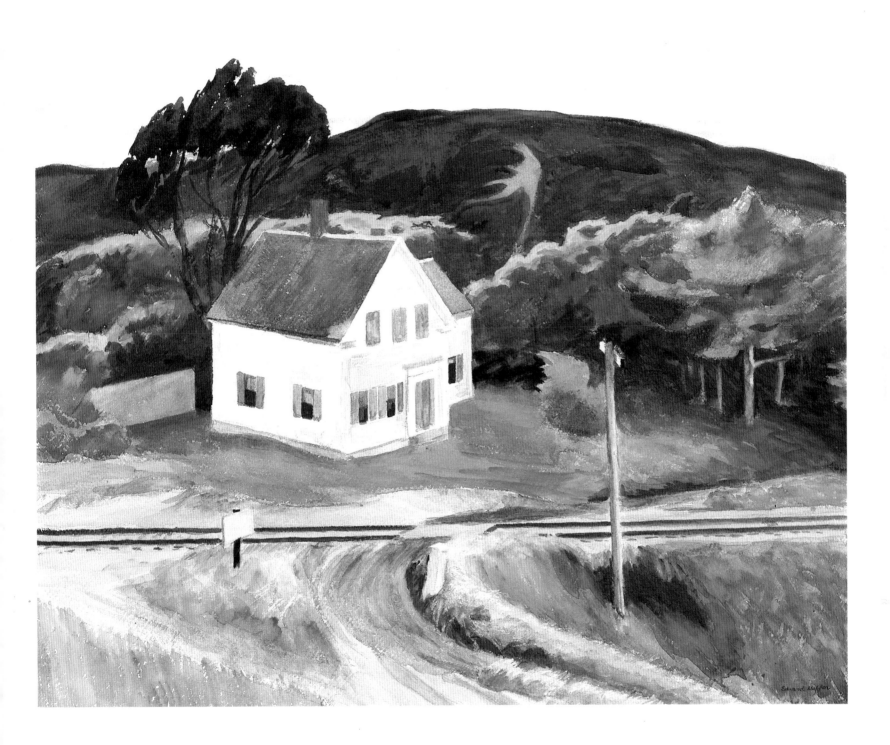

29
GAS, 1940
Oil on canvas
26¼ x 40¼ inches
The Museum of Modern Art, New York
Mrs. Simon Guggenheim Fund

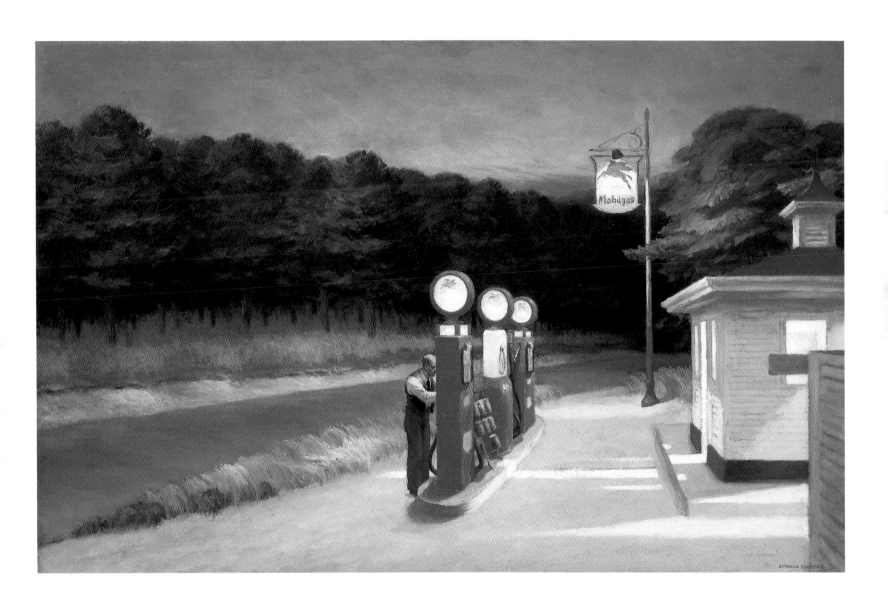

30
CAPE COD MORNING, 1950
Oil on canvas
34⅛ x 40¼ inches
National Museum of American Art, Washington, D.C.
Gift of the Sara Roby Foundation
Photograph courtesy of Art Resource, New York

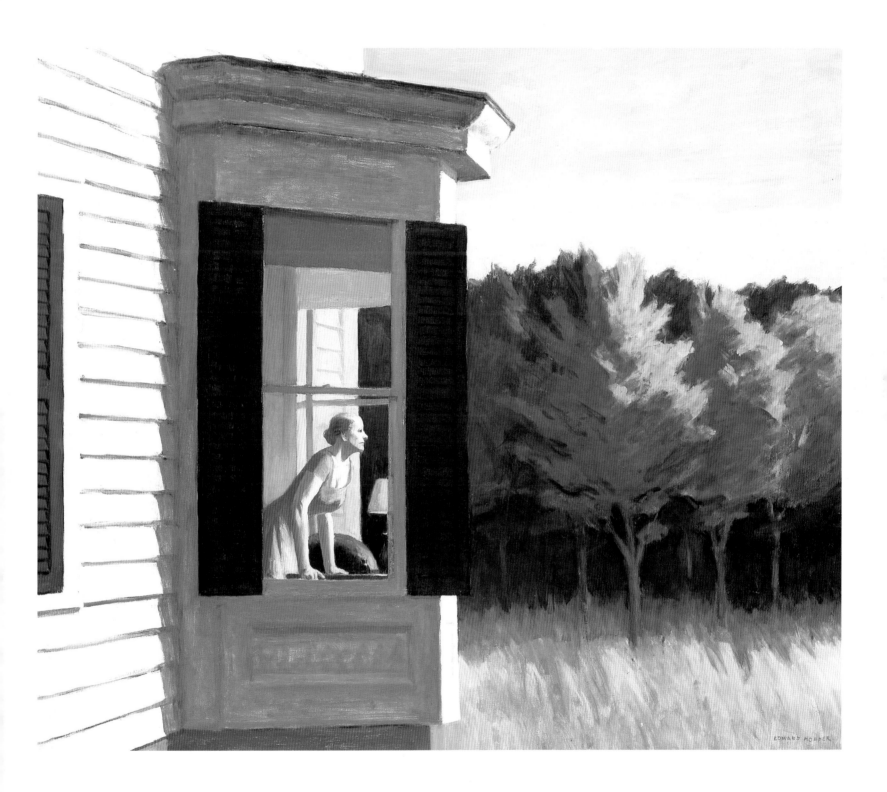

31
CAPE COD AFTERNOON, 1936
Oil on canvas
34 x 50 inches
The Carnegie Museum of Art
Patrons Art Fund, 38.2

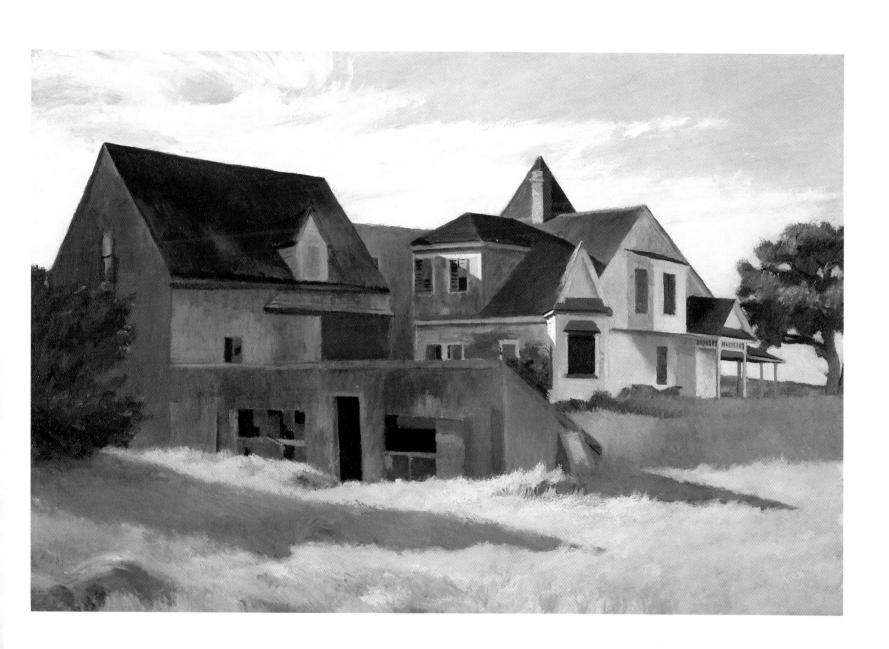

32
CAPE COD EVENING, 1939
Oil on canvas
30¼ x 40¼ inches
© 1993 National Gallery of Art, Washington, D.C.
John Hay Whitney Collection

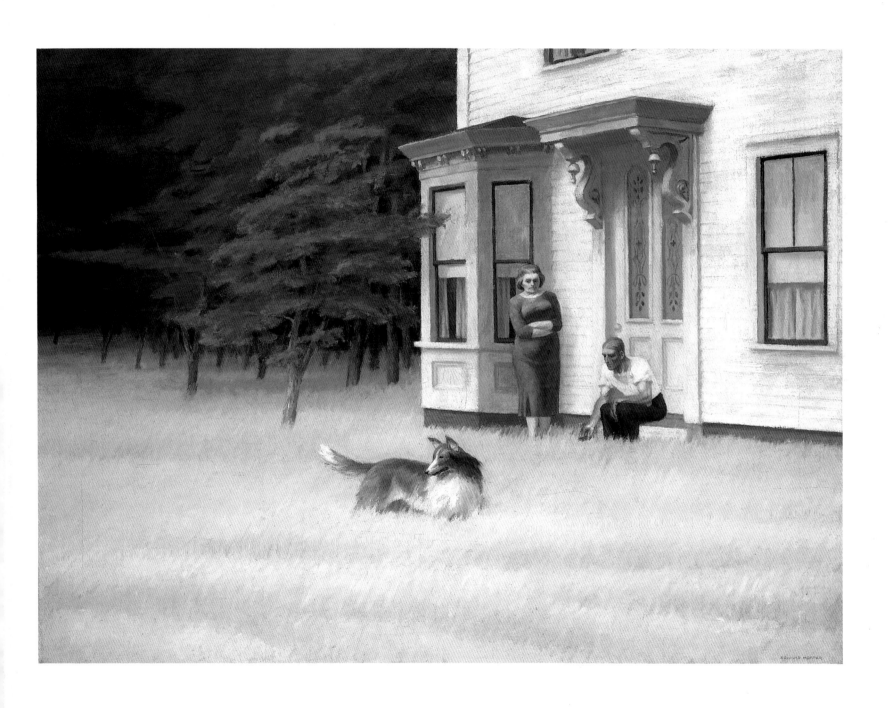

33
ROOMS FOR TOURISTS, 1945
Oil on canvas
30¼ x 42⅛ inches
Yale University Art Gallery
Bequest of Stephen Carlton Clark, B.A. 1903

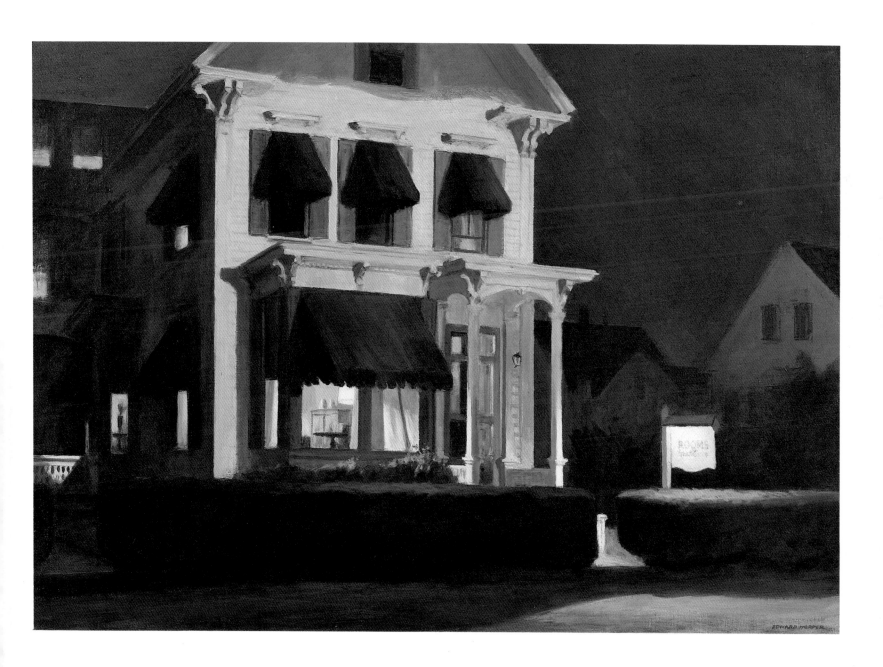

34
HIGH NOON, 1949
Oil on canvas
27½ x 39½ inches
The Dayton Art Institute
Gift of Mr. and Mrs. Anthony Haswell

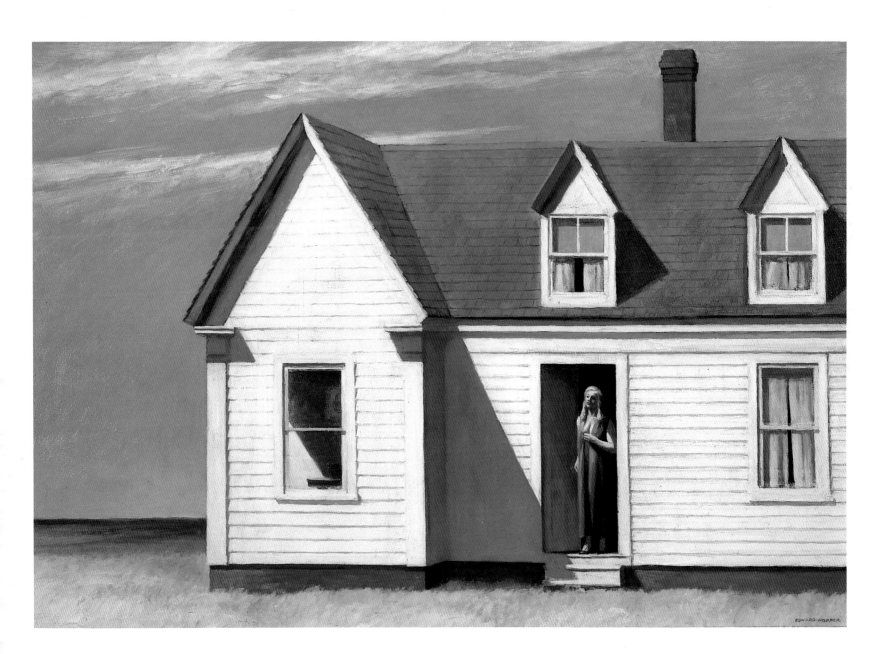

35
ROOMS BY THE SEA, 1951
Oil on canvas
29 x 40⅛ inches
Yale University Art Gallery
Bequest of Stephen Carlton Clark, B.A. 1903

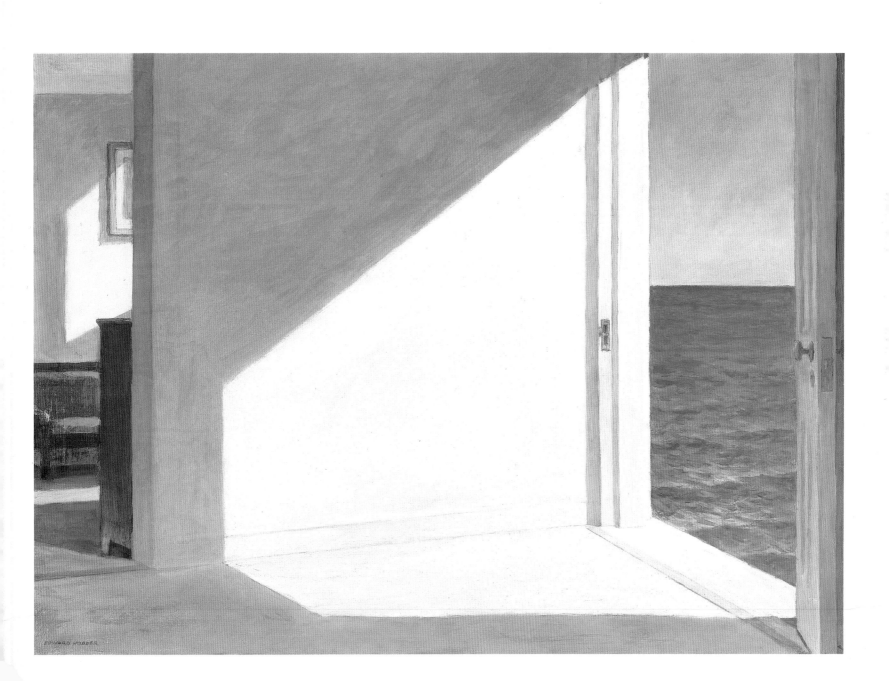

SELECTED BIBLIOGRAPHY

Barr, Alfred H., Jr. *Edward Hopper: Retrospective Exhibition.* New York: Museum of Modern Art, 1933.

Burchfield, Charles. "Hopper: Career of Silent Poetry." *Art News,* March 1950.

du Bois, Guy Pène. *Edward Hopper.* American Artists Series. New York: Whitney Museum of American Art, 1931.

Eliot, Alexander. *Three Hundred Years of American Painting.* New York: Time, Inc., 1957.

Goodrich, Lloyd. *Edward Hopper Retrospective Exhibition.* New York: Whitney Museum of American Art, 1950.

_____. *Edward Hopper.* New York: Whitney Museum of American Art, 1964.

_____. *Edward Hopper.* New York: Harry N. Abrams, Inc., 1983.

Gussow, Alan. *A Sense of Place: The Artist and the American Land.* New York: Friends of the Earth, 1971.

Henri, Robert. *The Art Spirit.* New York: J. B. Lippincott Company, 1923.

Hobbs, Robert. *Edward Hopper.* New York: Harry N. Abrams, Inc., 1987.

Hoopes, Donelson F. *American Watercolor Painting.* New York: Watson-Guptill, 1977.

_____. "Randall Davey, The New York-Santa Fe Connection." *American Art & Antiques,* January-February, 1979.

Hughes, Robert. *Nothing If Not Critical.* New York: Alfred A. Knopf, 1987.

Kroll, Leon. *A Spoken Memoir.* Charlottesville: University Press of Virginia, 1983.

Kuh, Katherine. *The Artist's Voice, Talks with Seventeen Artists.* New York: Harper & Row, 1962.

Levin, Gail. *Edward Hopper as Illustrator.* New York: W. W. Norton, 1979.

_____. *Edward Hopper: The Complete Prints.* New York: W. W. Norton, 1979.

_____. *Edward Hopper: The Art and the Artist.* New York: W. W. Norton, 1980.

_____. *Hopper's Places.* New York: Alfred A. Knopf, 1985.

Little, Carl, and Arnold Skolnick. *Paintings of Maine.* New York: Clarkson Potter, 1991.

Marling, Karal Ann. *Edward Hopper.* New York: Rizzoli, 1992.

O'Doherty, Brian. "Portrait: Edward Hopper," *Art in America,* September 1971.

Robertson, Bruce. *Reckoning with Winslow Homer: His Late Paintings and Their Influence,* Cleveland: The Cleveland Museum of Art, 1990.

Schjeldahl, Peter. *Edward Hopper: Light Years.* New York: Hirschl & Adler Galleries, Inc., 1988.

Strand, Mark. "Hopper: The Loneliness Factor." *Antaeus,* Spring 1985.

Ward, J. A. *American Silences: The Realism of James Agee, Walker Evans, and Edward Hopper.* Baton Rouge: Louisiana State University Press, 1985.

Wilmerding, John. *A History of American Marine Painting.* New York: Little, Brown & Company, 1968.